IMAGES
of America

QUABBIN VALLEY
PEOPLE AND PLACES

IMAGES
of America

QUABBIN VALLEY
PEOPLE AND PLACES

Elizabeth L. Peirce

ARCADIA
PUBLISHING

Published by Arcadia Publishing
Charleston SC, Chicago IL, Portsmouth NH, San Francisco CA

Printed in the United States of America

Library of Congress Catalog Card Number: 2006924310

For all general information contact Arcadia Publishing at:
Telephone 843-853-2070
Fax 843-853-0044
E-mail sales@arcadiapublishing.com
For customer service and orders:
Toll-Free 1-888-313-2665

Visit us on the Internet at http://www.arcadiapublishing.com

CONTENTS

ACKNOWLEDGMENTS

The response to my first book, *Lost Towns of the Quabbin Valley,* in 2003 was so enthusiastic that I began thinking about the many more pictures in the archives of the Swift River Valley Historical Society waiting to be shared and enjoyed.

This book entitled *Quabbin Valley People and Places* highlights the people and more about them.

Humble thanks to the board of directors for their confidence, to my children for their help and encouragement, and most especially to Betty-Sue Pratt, who assembled the final product.

INTRODUCTION

Lost Towns of the Quabbin Valley, published by Arcadia in 2003, was an overview of the fate that befell the Central Massachusetts towns of Dana, Enfield, Greenwich, and Prescott in 1938. That chapter of history is remembered as the sacrifice that made the Quabbin Reservoir possible.

This sequel to that story is entitled *Quabbin Valley People and Places*. This photographic history highlights the people who lived in the valley between 1750 and 1938, a time when survival depended on determination and ingenuity.

These people came willingly and left reluctantly. The valley was a land of opportunity where people could be free to do their own thing in harmony with nature and their fellow man. They were brave, proud, creative, determined, and endowed with a certain quality called "Yankee stubbornness." They had the stamina to meet the incredible challenges of New England weather. Money was not a concern because few people had any. It was the heyday of bartering.

From these early beginnings, communities began to jell and the area separated into four towns, each taking on a life of its own. Greenwich incorporated in 1754, Dana in 1801, Enfield in 1816, and Prescott in 1822. Dana and Enfield grew along industrial lines, harnessing available water power. Prescott and Greenwich, with rich soil, developed along agricultural lines raising large crops of grains, fruits, and vegetables for profit and the family table. Cloth was manufactured in Enfield. Buttons for clothing were also made there.

Shops in North Dana manufactured boxes used for shipping. The lakes of Greenwich were a seasonal source of ice needed to preserve food. The nearby railroad was utilized for shipping this product. Farmers needed wagons and horses, which needed wheels and shoes. Demand dictated supply. Nails, pails, pots and pans, buttons, brooms, and buggies were all made in response to a need.

Children needed to be educated. Schools were built and teachers employed. The need for recreation and contact with others was met with many clubs and groups, especially the Grange organization.

Growing and thriving until the early 1920s, the valley bustled with activity. When the ominous cloud of a takeover of this space to create a water supply became a reality, the spirit of the people collapsed and the demise of the towns followed.

These hardy New Englanders and how they lived in a place that is no more is reflected in the pictures and stories found in this book, *Quabbin Valley People and Places*.

One

RECREATION AND CELEBRATION

The good times in the valley were the glue that held the communities together. Anniversaries, birthdays, and weddings had special importance. Friends and relatives gathered to enjoy food, fellowship, music, poems, and modest gifts. A shivaree was sure to surprise newlyweds.

Clubs and groups with special interests gathered regularly. There was the Button Club, the Chrysanthemum Club, the Debating Society, the Music School, the Embroidery Club, the Quilting Club, the Quabbin Club, the Order of Red Men, and the Grange. The Grange (Patrons of Husbandry) was organized in 1867 to provide education, service, and companionship for isolated farm families. When Grange chapters merged or disincorporated in the valley in 1938, many a tear was shed.

Recreation varied with the seasons. Summer meant picnics, reunions, fishing, swimming, and hours of croquet games. Fourth of July, Memorial Day, centennials, and bicentennials involved everyone. Thanksgiving and Christmas were family holidays.

Work and play were combined in the fall. Husking bees where neighbors helped neighbors were followed by cider and doughnuts and maybe a dance. Halloween meant deviltry, especially for the young men and boys. Outhouses were tipped over, church bells rung, and firecrackers were thrown into the town watering tub. The object of it all was not to get caught!

In winter there were sliding parties and skating parties. There were sleigh rides that usually included an oyster supper and dance at the Grange hall before the return trip home.

The pictures in this chapter recall many of the good times.

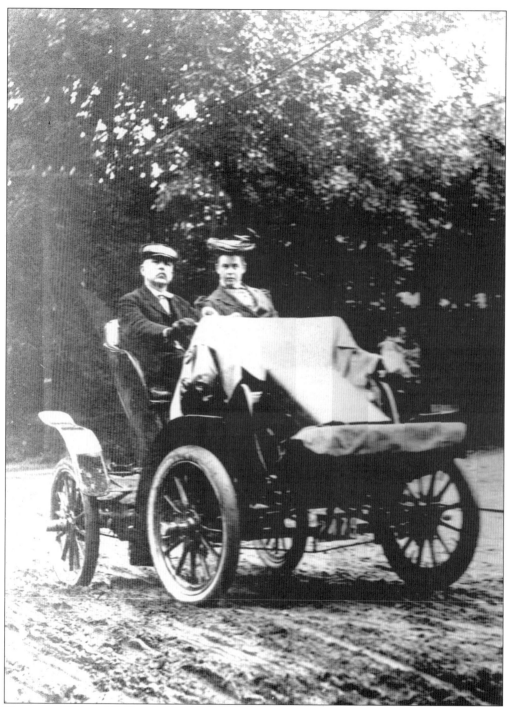

The year is 1901, and C. F. and Abagail Roper (née Taylor) are on a trip in their Pierce convertible. The eight-horsepower engine averaged eight miles per hour on a long trip. The speed was accelerated by two levers, and the vehicle was steered by a handlebar. There is a suitcase in the front seat. Abagail was the daughter of Lavinia Taylor (née Crossett) of Prescott.

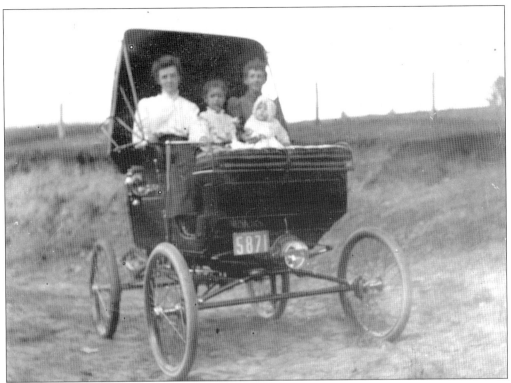

Members of the Vaughn family are enjoying a ride in their horseless carriage. The license plate number 5871 is prominently displayed.

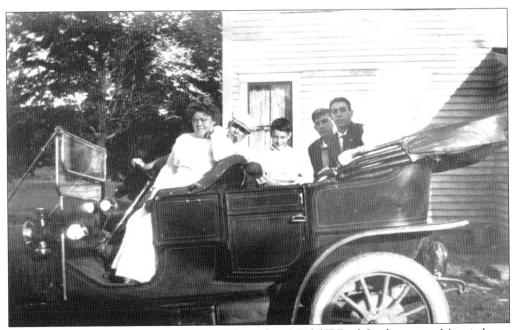

The Lego family members are ready for a ride in their Model-T Ford. In the car are Minnie Lego, Henry Lego, Fred Lego, and Raymond Lego.

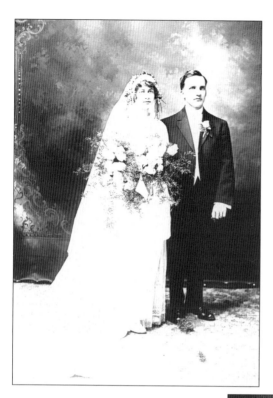

This unidentified couple poses for a formal wedding picture.

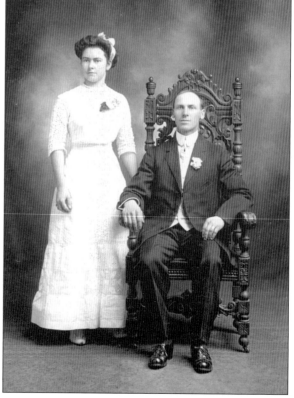

This wedding picture shows Cyprian Uracius and his bride, June Pulsifer, following their marriage on August 7, 1912. Cyprian was born in Russia and was naturalized on February 17, 1913. He served the town of Greenwich for 23 years, 12 years as constable. He was also a cemetery commissioner, a selectman, an assessor, a surveyor, and a member of the welfare board. He was among the very last occupants to leave his beloved Greenwich.

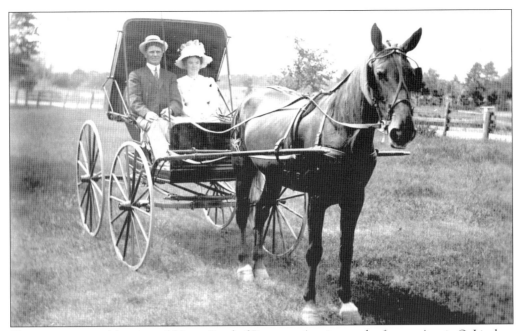

Here is a picture of Annie and Harry Reed of Prescott. Annie was the former Annie O. Lindsey of Prescott. They are newly married, and the date is April 10, 1912.

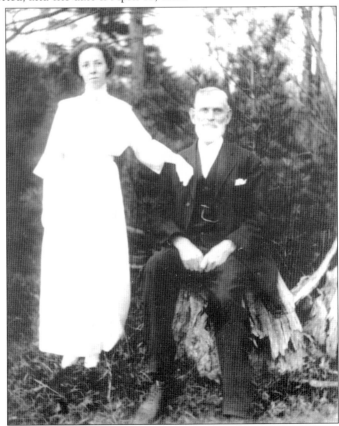

This is Burt Brooks and his second wife, Ina. Burt was a well-known photographer and painter in Greenwich. He was fond of making self-portraits, and this probably is one of them.

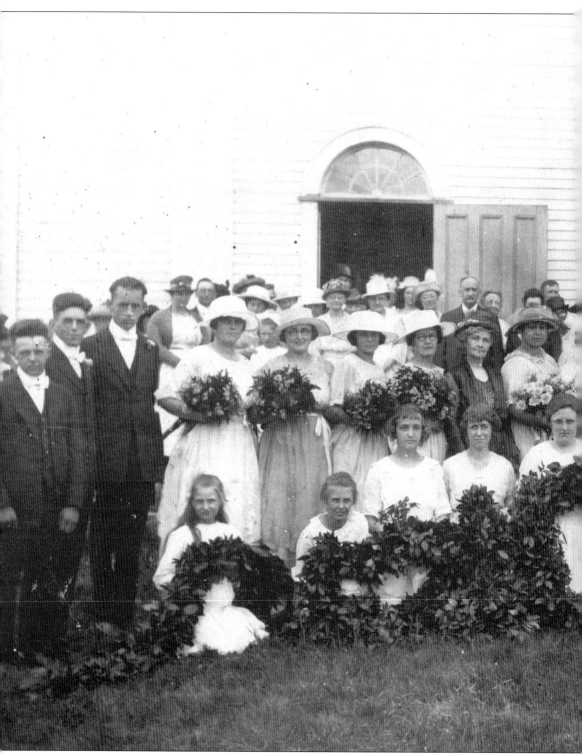

This picture shows the wedding party of Marion Hall to the Reverend Clarence G. Hall of Greenwich. The wedding took place on September 6, 1920, at the Greenwich

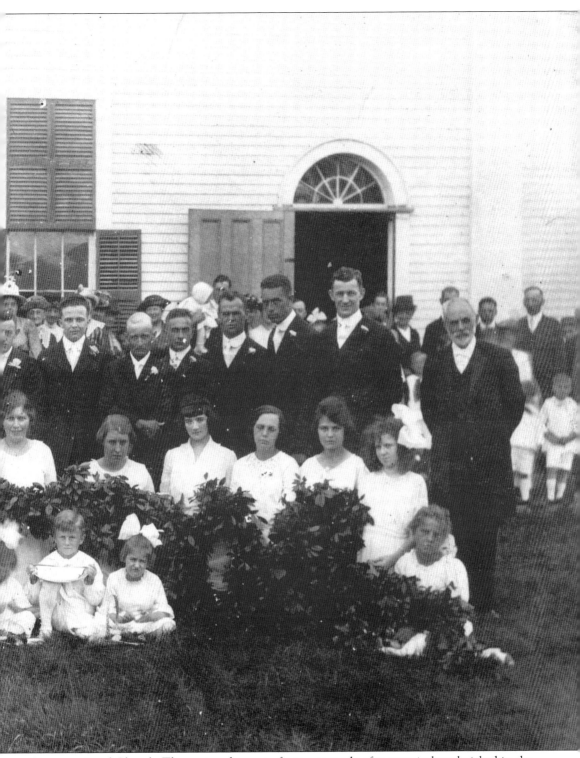

Congregational Church. The roping shown in front was made of mountain laurel picked in the Greenwich woods.

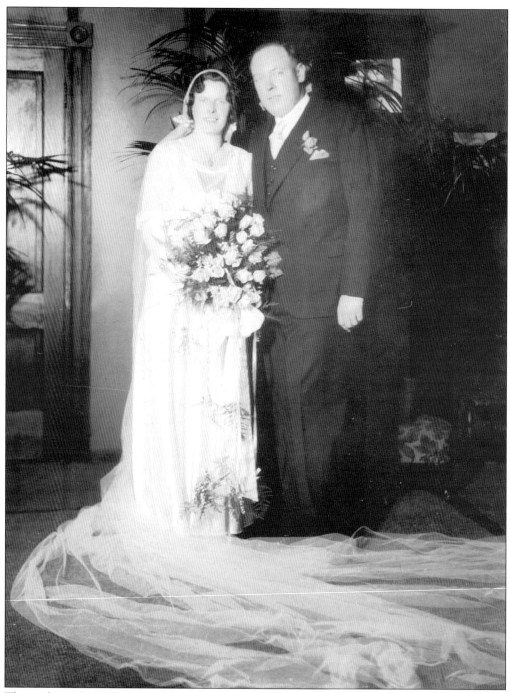

This is the wedding picture of Gertrude Whitney Ward and James Avery Stalbird. The wedding took place in the Enfield Congregational Church on November 18, 1933. It was the last wedding performed there before the church was mysteriously burned.

Maggie Mullins, pictured here with the altar boy who may be her brother, is celebrating her confirmation, an important milestone in the Catholic faith. The only Catholic church in the valley was St. Anne's in North Dana.

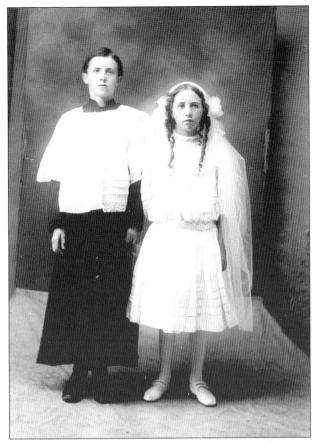

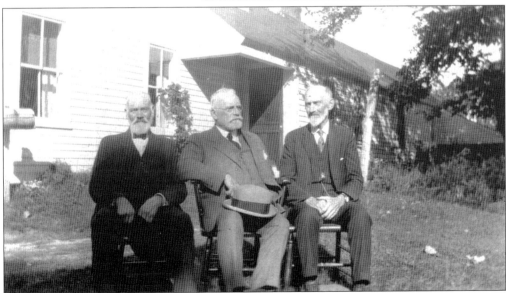

Brothers Prentis, George, and Cyrus Pierce are enjoying the sun and no doubt talking about the good old days. The date is September 19, 1923, and the occasion is the 85th birthday of Prentis.

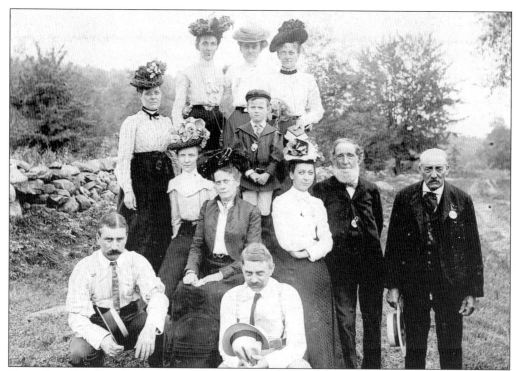

Dressed in their best finery, these folks are on the way to the Dana centennial parade in 1901. The group includes Lizzie Kelley, Clara Sprague Cook, Ella Carter, Jennie Thompson, Abbie Thompson, Mr. and Mrs. Clark, Elbridge Sprague, and Frederick H. Sprague.

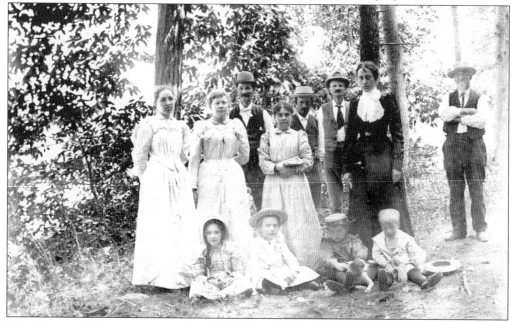

The identity of this group is not known. They may be gathered to watch a parade. The little girl at the left in the front row is wearing a Shaker bonnet similar to those made in the North Dana Hat Shop.

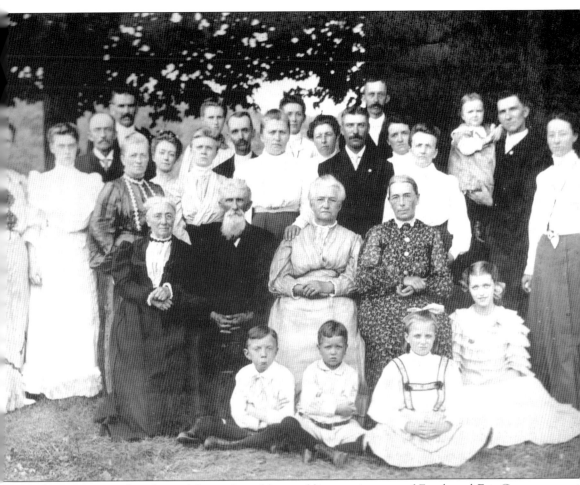

This group is gathered to celebrate the golden wedding anniversary of Frank and Eva Grover of North Dana. Frank was a prominent businessman and served in many town offices. He was co-owner of the Swift River Box Company with Charles Gee, and at one time co-owner with Henry Goodman in the manufacturing of hats. The little boy at the left in the front row does not appear to be having any fun.

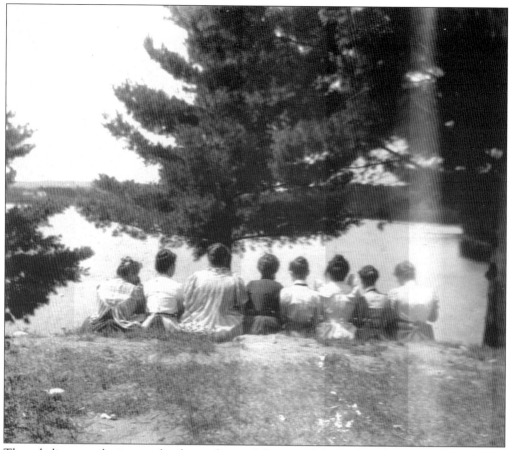

These ladies are relaxing on the shore of one of the many lakes in North Dana. Their identity is not known.

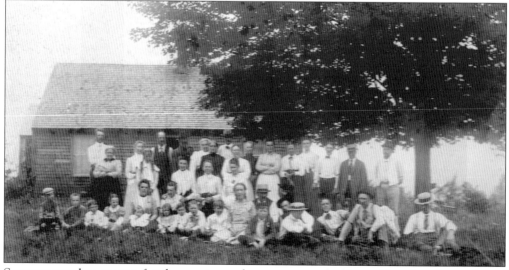

Summer weather meant family reunions when young and old would gather for a day of togetherness with plenty of food and games.

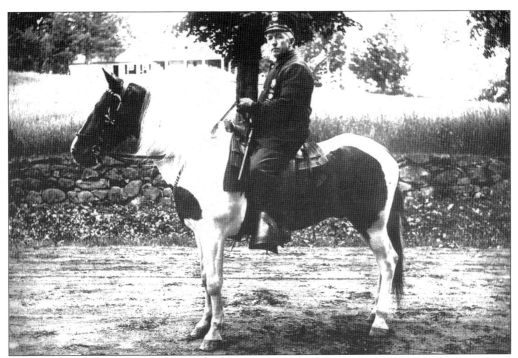

Parades were popular events in the Quabbin Valley towns, and nearly everyone got involved. In 1910, the former town of Enfield celebrated 100 years with many special events. This picture shows Thomas Sanderson, parade marshal.

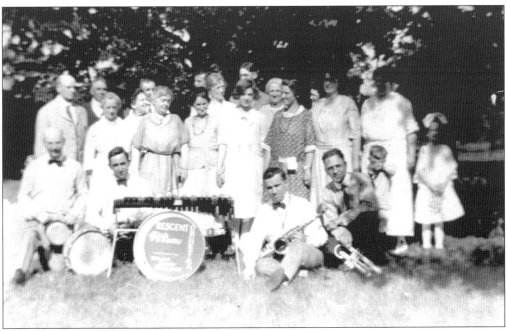

Reunions, weddings, anniversaries, and other special events almost always included some kind of music. The Rescent Orchestra is entertaining this group. On the drum is written "Music for all Occasions, Pleasant Street Amherst, Mass. Tel 4124 W."

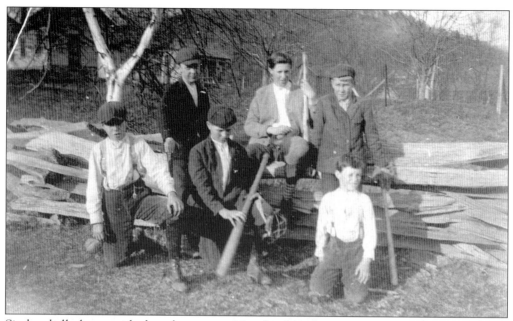

Six baseball players with three bats are waiting for the other team to arrive. Francis Parker is sitting on the fence holding a bat.

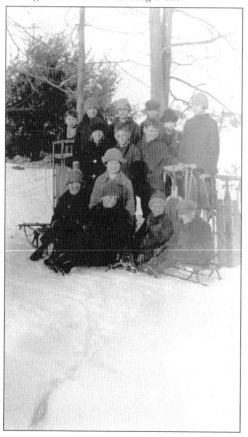

This group of smiling children poses as they prepare for an afternoon of sliding on their Flexible Flyers.

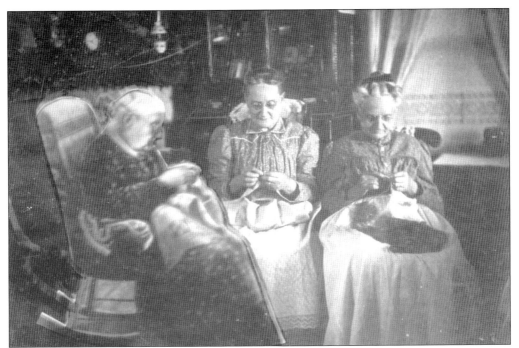

The lady at the left is Grandma Brooks, mother of Burt Brooks, a well-known photographer and painter from Greenwich. Some time after the death of his mother, Burt added this painted picture of her to a picture with the other two ladies. Why he did this remains a mystery. The names of the other two ladies are Martha Jane and Ann Maria.

George G. Sprague of North Dana is enjoying some quality time with his dog and his granddaughter, Helen Doane. She became Helen Nickerson in later years and was a much loved and well-remembered teacher in North Dana.

This gentleman is Fred E. Stevens, born in 1852, the oldest citizen in North Dana at the time the picture was taken. He poses with the gold-headed cane, which he was awarded for his longevity. The *Boston Post* newspaper awarded 323 of these canes throughout New England as a promotion for their paper. The tradition is still carried on. However, today the cane itself is often kept on display in the town hall and the honored person receives a replica lapel pin. Originally the award went to the oldest male. Today it goes to the oldest man or woman. At age 96, he had the distinguished honor of holding two gold-head canes—one from Dana and one from Athol, where he resided after he was forced to leave Dana.

Herbert and Mabel Campbell were owners of the Model Bakery in Enfield. Here they are shown enjoying a quiet moment in their home. (Courtesy of Linda Hanscom.)

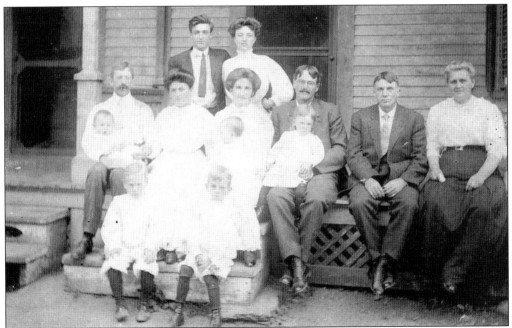

This family reunion took place in Greenwich on August 1, 1909. Present were Mr. and Mrs. William R. Johnson; Mr. and Mrs. Edgar W. Coit; Everett G. Coit, 1 year, 11 months old; Clarence F. Coit, 10 months old; Mr. and Mrs. John H. King; Gladys M. King, 1 year, 6 months old; C. Herman King, 5 years, 6 months old; Ralph C. Robbins Jr., 5 years, 6 months old; Ralph Robbins; and Mrs. William R. Johnson Jr.

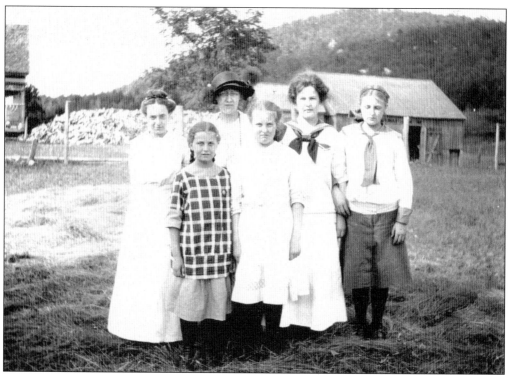

These Greenwich Village ladies are, from left to right, Helen Hall, Vera Hall, Evelyn Hall Loux, Frances Hall, Marion Hall, and Dorothy Hall. The picture was taken at the Alfred King farm. A note on the back of the photograph calls attention to the woodpile of 20 cords in the background.

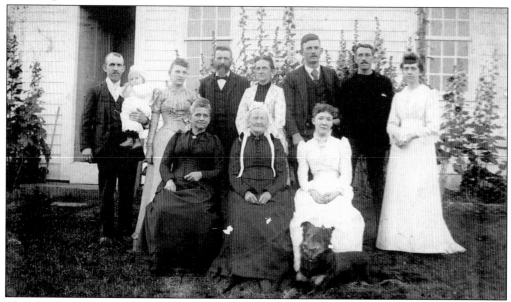

This family group is gathered for a special occasion. From left to right are (first row) Sarah Morse; grandma Selina Stetson Morse; and Nellie Parker; (second row) Frank, baby Sam, and Gertrude Derby; Oscar Morse; Fannie Parker; Frank Parker; Arthur Morse; and Mabel Morse.

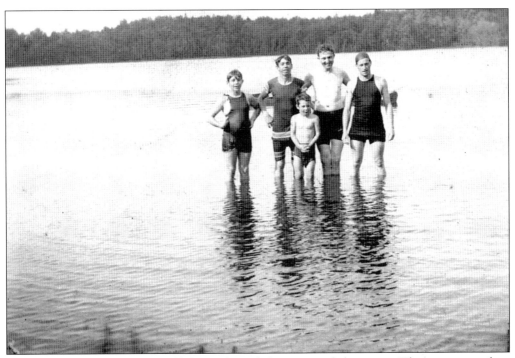

Greenwich had many ponds and lakes with sandy bottoms and clear water. This group is cooling off in Warner Pond. The year is 1913.

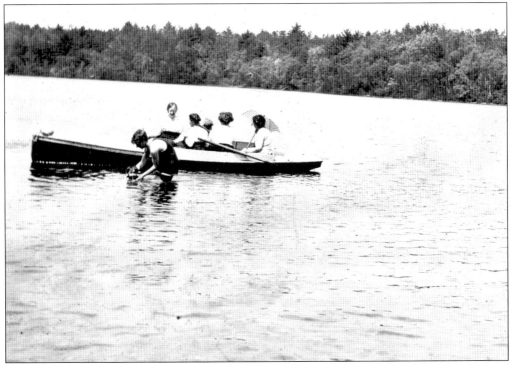

The largest body of water in Greenwich was Quabbin Lake. This picture was taken by Burt Brooks. Some members of his family are enjoying a summer day.

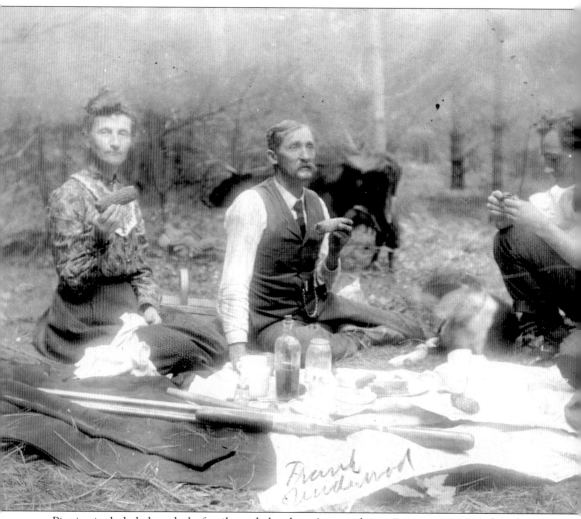

Picnics included the whole family and the dog. An article on "picnic-giving" is found in an 1894 *Deliniator* magazine. It describes the best site for a picnic, the proper food (never pie), and choosing a day "beyond suspicion." It details the proper attire for a woman, "a skirt or jacket of woolen and a silk or linen shirt-waist. A large hat should never be worn to a picnic."

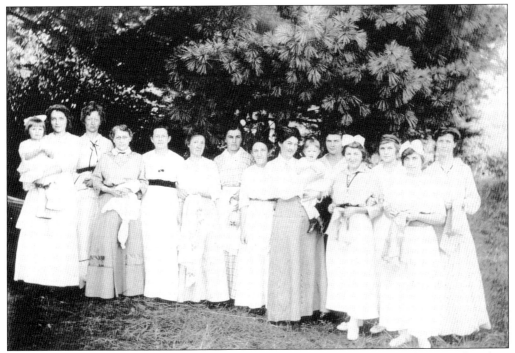

This picture shows the Embroidery Club in Enfield. This form of "art in stitches" was found on towels, sheets, and clothing, and was framed to hang on the wall. These ladies along with small children have met to enjoy a common interest.

Lucius Lawless, Emeline Haskins (née Lawless), and Cora Fisher enjoy a moment of relaxation in the warm sunshine.

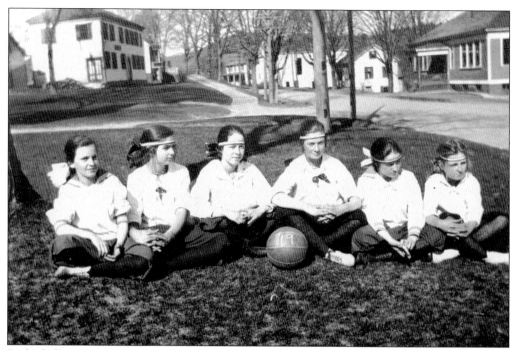

Basketball was a popular sport for girls and boys. These young ladies, all eighth graders, pose on the Enfield common in 1919. Vivian Gilpin, third from the left, is the only one identified. Their modest uniforms consisted of bloomers and middies, black stockings, and matching headbands.

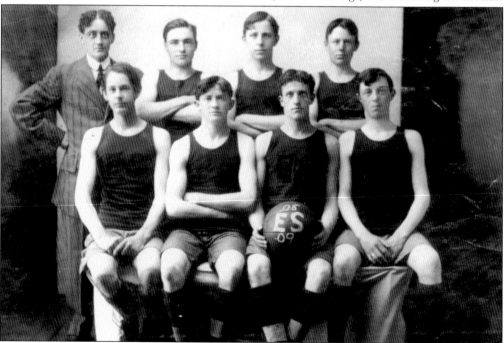

Here is the Enfield basketball team in 1909. From left to right are (first row) Roy Gage, Harrison Johnston, Homer Damon, and Ralph Randall; (second row) Edward Rohan, Richard Downing, Chester Pike, and Robert Stone.

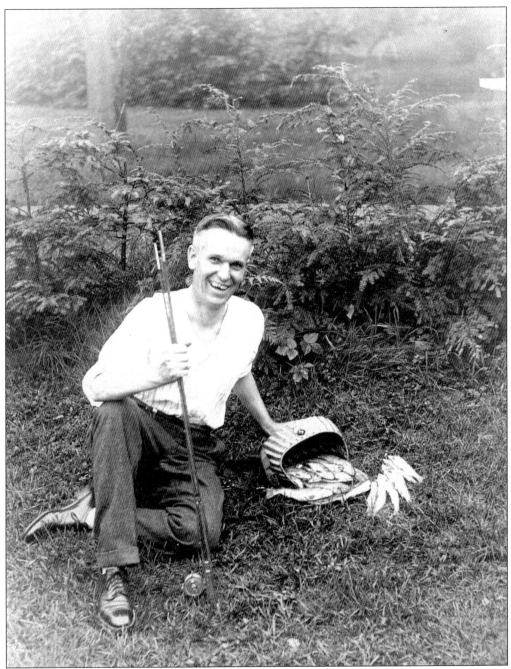

The brooks and streams in the Quabbin Valley provided some excellent fishing, and every fisherman had his favorite and often secret spot. This man is obviously pleased with his catch of the day. It appears that he dressed up to have his picture taken.

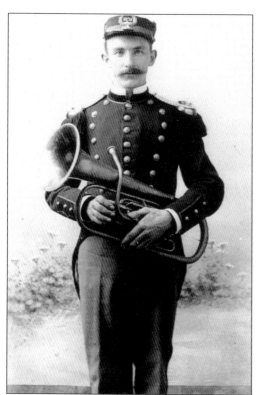

This young musician wearing the uniform of the Enfield Cornet Band poses with his baritone horn.

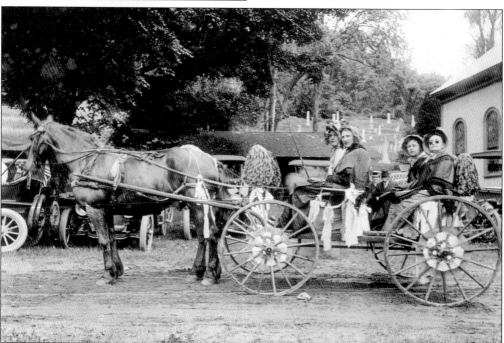

This picture shows one of the many entries in the centennial parade in Enfield in 1916. The corner of the Enfield Congregational Church shows at the far right. The cemetery can be seen in the background. Today the waterline is even with the curbing around the cemetery.

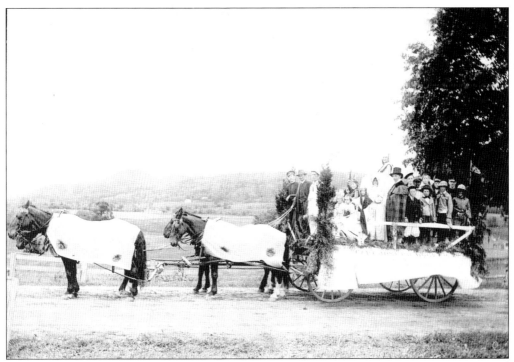

This float is the Daughters of the American Revolution entry in the 1916 centennial parade and honors Gen. Joseph Hooker. Two teams of horses draw the float because of the weight.

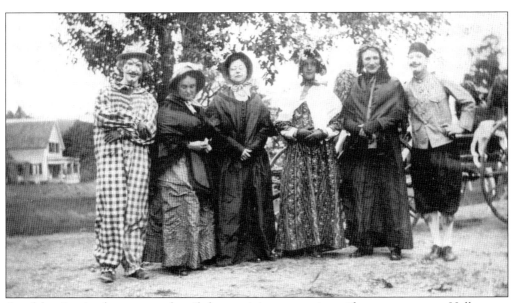

A celebration is always more fun if the participants are in uniform or costume. Halloween, for instance, loses its excitement without costumes. These folks have gotten into the spirit by dressing as clowns. It is not known if they were participants or spectators.

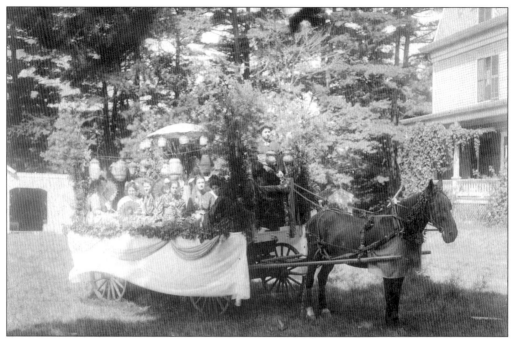

This picture was taken in 1910 and shows a parade entry on the occasion of a school reunion and Old Home Day in North Dana. The ladies riding are, from left to right, Emma Grover, Effie Holland, Jennie Carey, Eva Ray, Irene Canuel, and Bertha Ellis. Ida Carey is driving. Even the horse is in costume.

This picture was put with recreation because the man does not appear serious about cutting wood. With little regard for the rocking chair he is using to hold the wood, he is using a bucksaw.

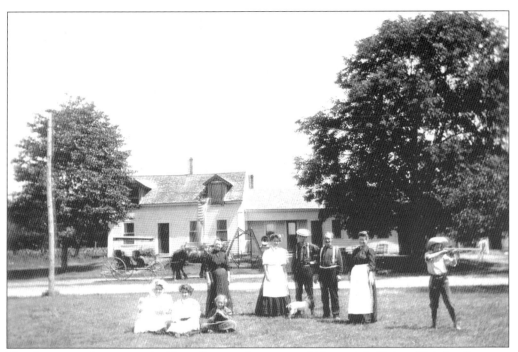

This home was known as the Elmer Powers place, east of Greenwich Plains. This family group shows a little girl at the left dressed like a bride and holding a doll. Another child holds a book, and at the far right is a boy aiming a gun. In the background can be seen a surrey; a buggy with two seats facing forward and a seat in front for the driver.

This picture shows Lowell Parker holding the reins as he takes his sister Doris and a friend for a ride in the pony cart.

This picture shows a horse and buggy in front of the Riverside Hotel in Greenwich Village. The dog is paying good attention.

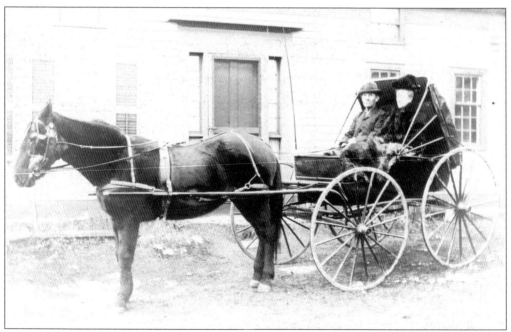

Edwin and Orissa Horr of North Dana are setting out for a buggy ride. Orissa has a buffalo robe across her lap.

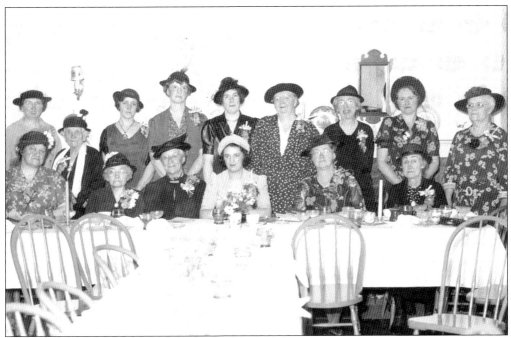

This is the last banquet of the Enfield Quabbin Club on April 12, 1938. This organization was devoted to community service.

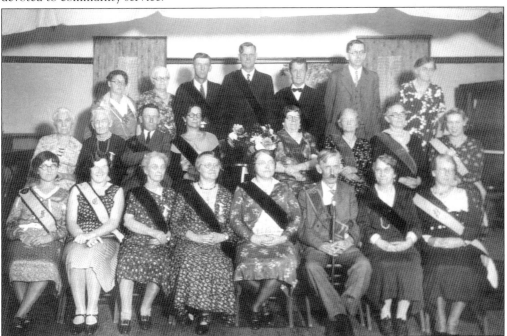

This picture shows the final gathering of the Enfield Grange. From left to right are (first row) ? Fielding, G. Ward, Mrs. Webber, B. Fargo, Mrs. Felton, J. Paine, E. Johnson, and F. Rafters; (second row) Mrs. Felton, Mrs. Cutting, William Fielding, D. Foley, G. Heidel, C. Steen, Grace Smith, and M. Rafters; (third row) Mrs. Wilder, Inez Brown, H. Fargo, E. Rafters, H. Johnson, E. Heidel, and L. Olds.

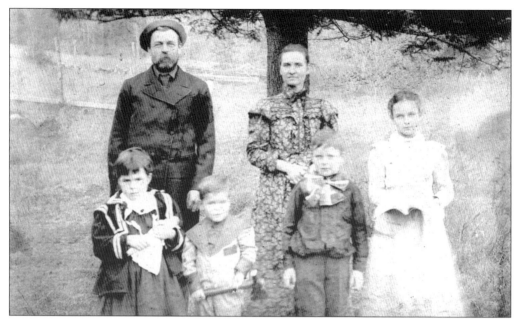

In this unidentified family group, the little girl at the left holds a doll. The smallest boy has a croquet mallet, and the oldest girl holds an open book.

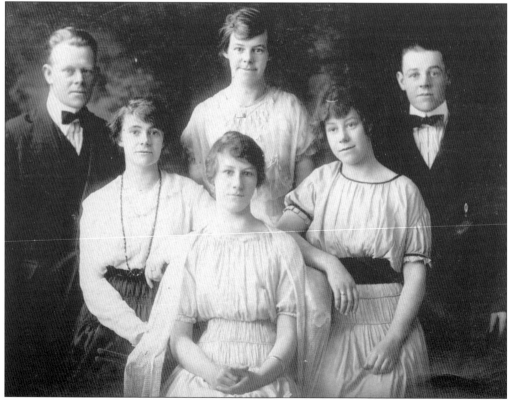

Here are the children of Mr. and Mrs. Dwight Cooley of North Dana. They are, from left to right, (first row) Felice, Pearl, and Sadie; (second row) Leon, Hazel, and Leslie.

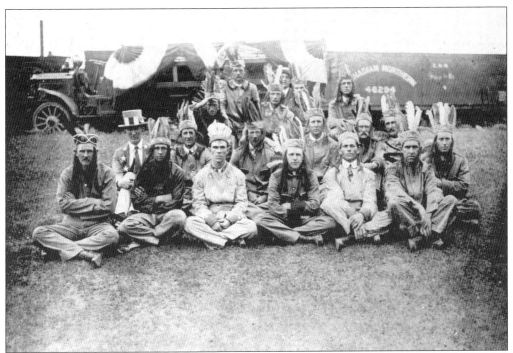

This picture shows the Improved Order of Red Men in North Dana. This fraternal society was (and still is) active with members throughout the United States. Members are organized into lodges, and their dues are used to benefit members in case of sickness, accidents, and death.

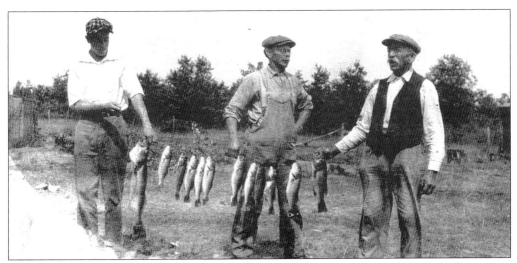

The fish were really biting on this day! The big one did not get away either. Note the man at the left.

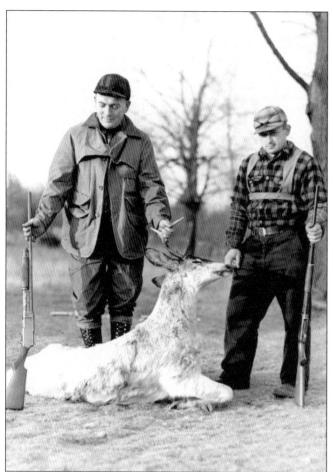

Stories were told and retold of sightings of an albino deer in the Prescott hills. The stories were heard with skepticism until these hunters proved the stories were true.

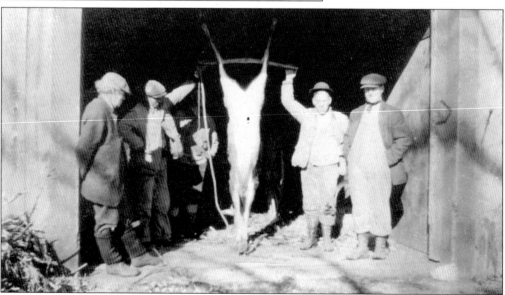

Here, back from a successful hunt, these hunters display their prize.

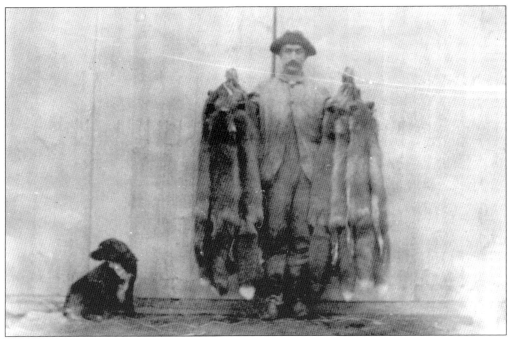

Here is Howard Vaughn with all the foxes he can carry. A fox fur was a coveted piece of adornment for a lady. It could be red or gray. Today furs are politically incorrect, and foxes are no longer hunted for their fur.

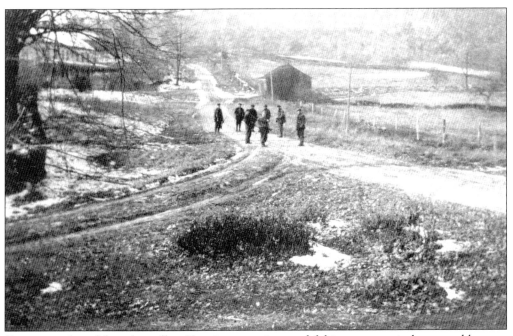

Game was plentiful in the valley. Hunting, trapping, and fishing were actively pursued by men and boys. Deer season, traditionally the first week of December, was eagerly awaited. Early snow made tracking easy, and large groups of hunters went out together with a planned strategy. Here is a group ready to go in Atkinson Hollow, Prescott.

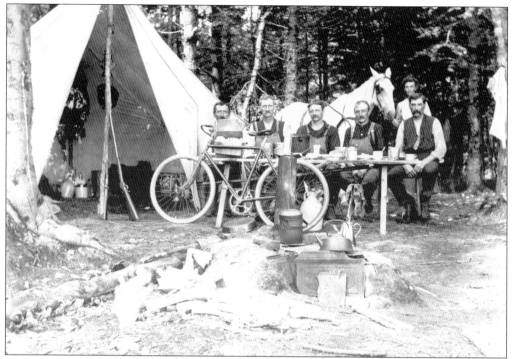

This campsite of the Vaughn family defies description or an explanation. Fun was much simpler in the old days.

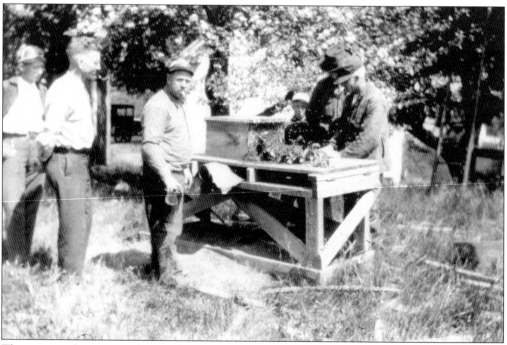

This group of men is gathering for the annual ritual of cleaning the bee hives after taking out the combs of honey. On display at Swift River Valley Historical Society is a unique honey extractor. It is handmade and a fine example of Yankee ingenuity.

Two

PLACES

There were many kinds of places in the Quabbin Valley—places of beauty, places where people lived, and places where people worked.

Before streets and roads were identified by name, places were called by the name of the people living there or the name of someone who used to live there. A place of business was easy to establish, one could just do it. There were no rules, regulations, or environmental concerns. Life was much simpler, but probably not better, and certainly not safer, as the number of fires and accidents proved.

This chapter highlights some of the places of beauty, some of the homes, and several places of business.

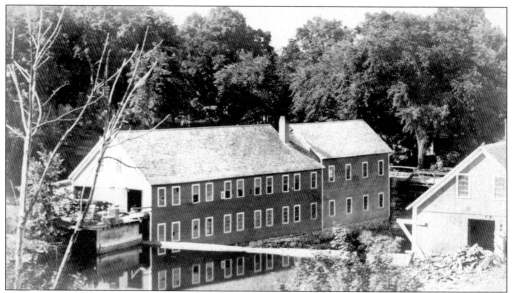

The New England Box Company in Greenwich was operated by Stephen Bailey. Born in 1818, he came to Greenwich at the age of six. As a young man he was a farmer, for 70 years he was a lumber merchant. He was one of the town's most successful citizens. Although this shop appears large, it employed about 30 people in the making of wooden boxes for shipping.

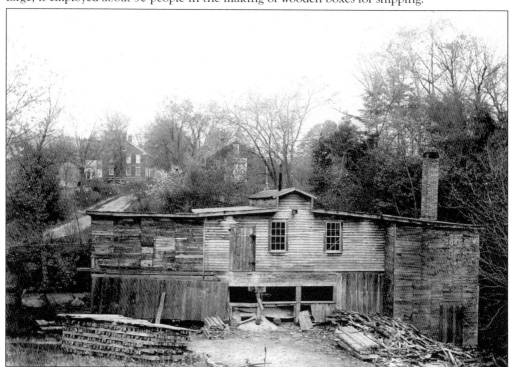

This picture shows Samuel Whiting's mill. The mill was located in Doubleday Village in North Dana. It had been previously owned by Nehemiah Doubleday and C. Edward Goodman. Doubleday Village in North Dana was so named because of a cluster of seven homes, all owned and occupied by Doubleday families.

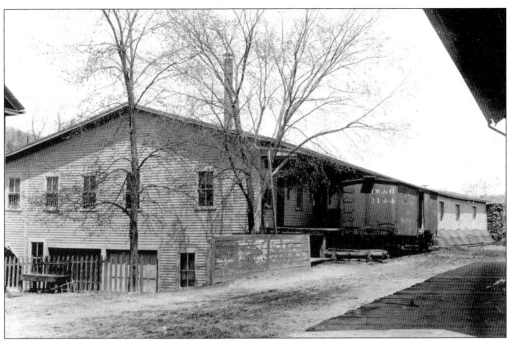

This shop in Enfield, owned by Cyrus F. Woods, is where boxes were manufactured. Cyrus Woods came to Enfield in 1851 and operated a dry goods store there. Later he was engaged in the box making business. Note the convenience of the boxcar for shipping the final product.

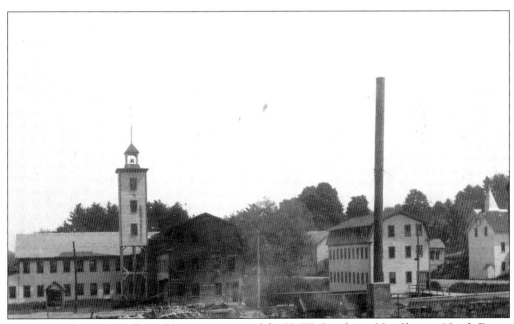

This scene shows the still-smoldering remains of the H. W. Goodman Hat Shop in North Dana. Between 1850 and 1868, the shop burned four times, each time being rebuilt. Its last use was as the Tyler Crawford Mill, where satinet cloth was made.

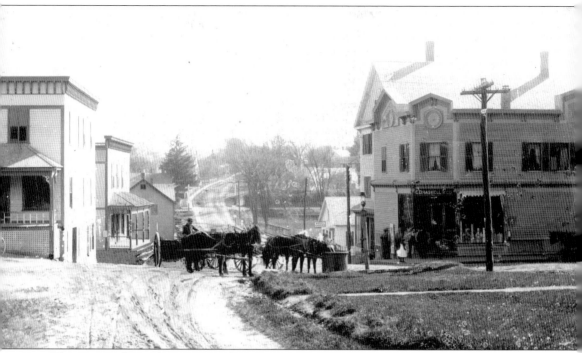

This picture shows the center of the business district of Enfield. The building on the right was the Haskell Block, next the C. W. Felton Block, and Campbell's Bakery was next in the small white building. To the left is the Barlow Block, Isaac Bestor's store (later the Lisk's Pool Room), and beyond, the gristmill. The watering trough is conveniently located in the center of town.

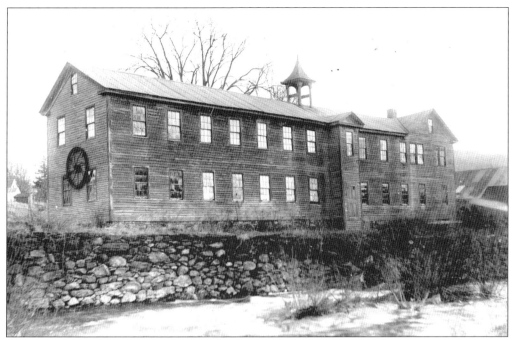

Shown in this picture is the back side of the weave shed of the Enfield Manufacturing Company, part of the Tebo Mill.

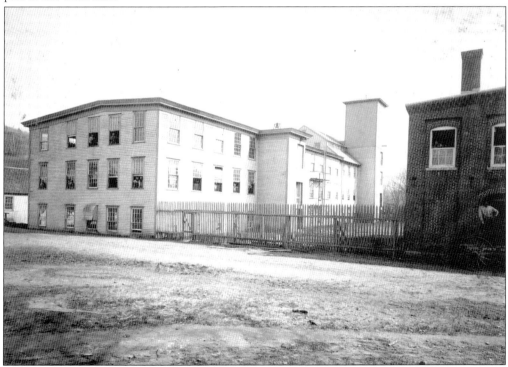

Here is the woolen mill of the Swift River Company in Smith's Village. Smith's Village was part of Enfield and consisted of several buildings and rows of houses for employees. It had its own post office and school.

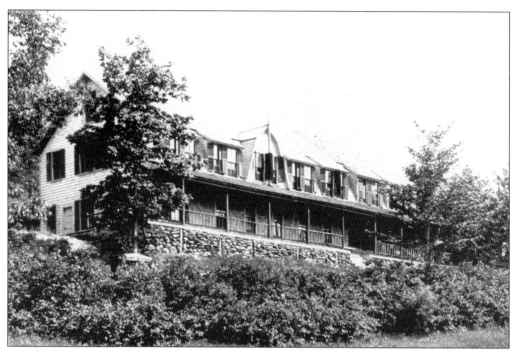

The Quabbin Inn in Greenwich was situated overlooking the lovely Quabbin Lake. It was a summer resort for people from Springfield to Boston with a yen for the country in summer. In later years, the YMCA used it as a summer camp.

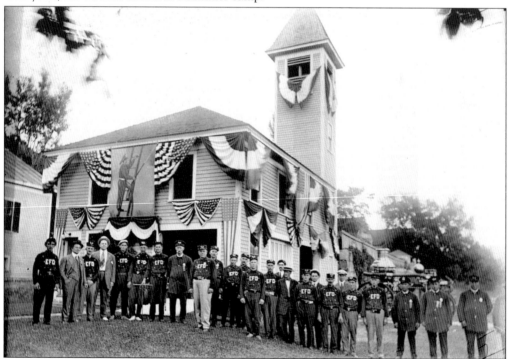

This picture shows the volunteer firemen of Enfield. The fire station is decorated with red, white, and blue bunting as the town celebrated its birthday in 1916.

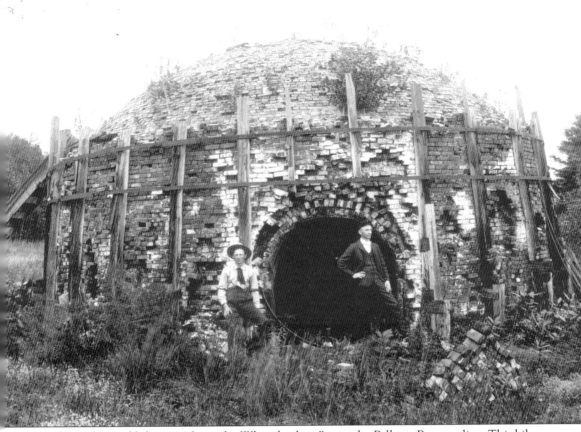

The large charcoal kiln was "above the Whipple place," near the Pelham-Prescott line. This kiln was owned by George Corser and H. F. Moulton, seen in the picture. The kiln would be tightly stacked with wood, closed, and burned until the wood was reduced to charcoal. It was then used in the Corser-Moulton foundry in Ware. Another kiln on the Prescott-Dana line was tended by a resident named Billie Burke. He was notorious for consuming large quantities of liquor while waiting for the charcoal to "cook."

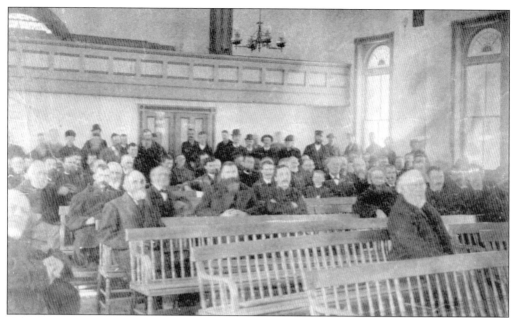

Town meetings were strictly for men prior to 1920 when women were allowed to vote. Some things never change, there are empty seats in the front rows. This meeting is taking place in the Congregational church in North Dana.

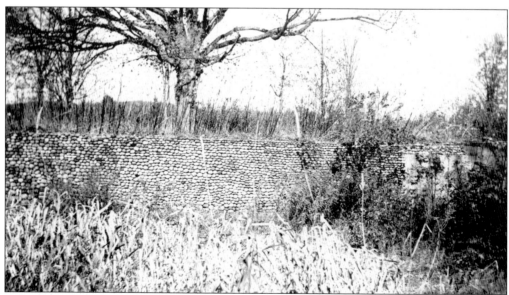

This stone wall was built on the Vaughan property on Dana common. Cellar holes are visible as well. This is a favorite place to visit since it is not in the restricted area of the Quabbin Reservior, although it is part of the watershed.

Rattlesnake Mountain on the west side of Prescott rose 300 feet from the base. There is no record of rattlesnakes being seen there. At the base, an opening probably made by falling rocks was called the "ice cave" because ice could be found there year round.

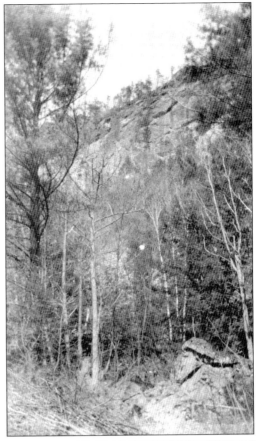

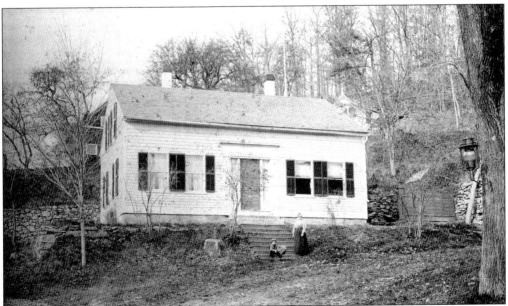

This picture of a homesite shows an oil or kerosene lantern attached to the tree on the right. The lamp was lit by a long pole with a lighted rag on the end.

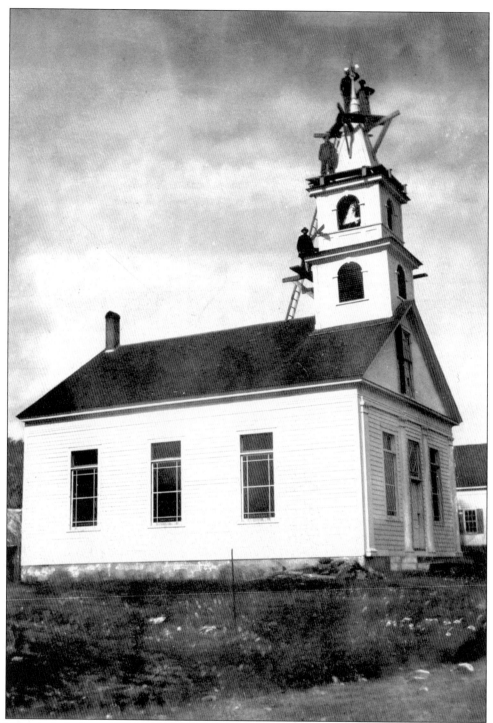

This church, built in 1837, was located at the very edge of the Quabbin Reservoir, necessitating its removal. Originally a Methodist Episcopal church, it is now the Prescott Museum, part of the Swift River Valley Historical Society, and located on the grounds in North New Salem. The steeple is receiving paint and repairs in this picture.

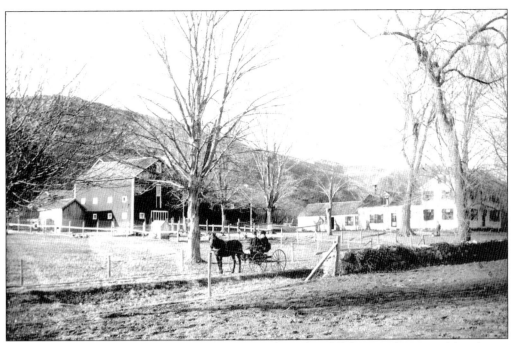

This is the Felton place in Enfield. An early spring day or late fall day, any day is good for a buggy ride. A painting of this homestead by an unidentified painter can be seen at the Swift River Historical Society.

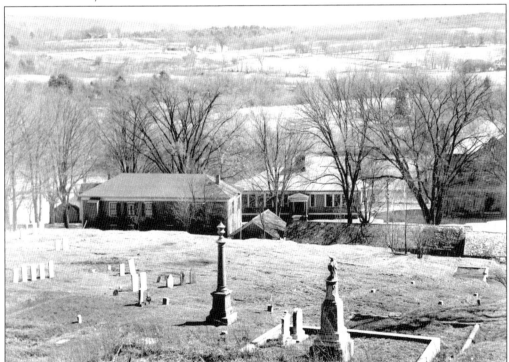

This is a scene overlooking Enfield from the cemetery. The water now covers all but a few pieces of the curbing stone that are visible today.

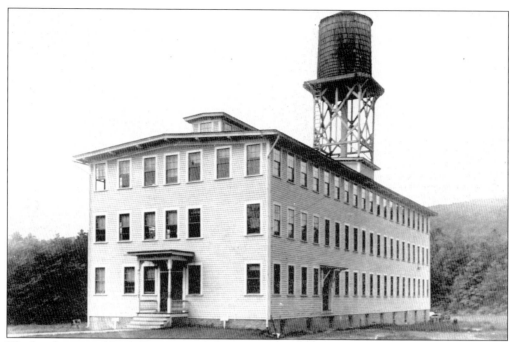

The hat factory in North Dana provided work for men, women, and children of at least 15 years of age. The braiding of palm leaf hats was a cottage industry that women and girls embraced as a way to earn a little money. The palm leaves were brought from South America. They were soaked, split, and then hand braided into hats. They were then picked up, taken to the hat factory, and finished with bands and labels.

Many stories have been told and several books written on the subject of Shays' Rebellion and the instigator Daniel Shays. This picture shows the Conkey Tavern in Prescott where it is said the rebellion was planned.

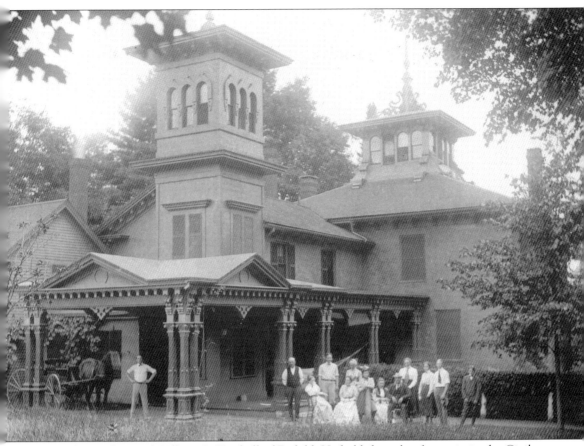

This is the residence of William B. Kimball of Enfield. He held the title of captain in the Civil War and later was prominent in town affairs. This showpiece home belonged to his wife Fanny's family, the Josiah Woods. The building was used by the Metropolitan District Commission during the building of the reservoir and was the last building to be demolished, in 1938.

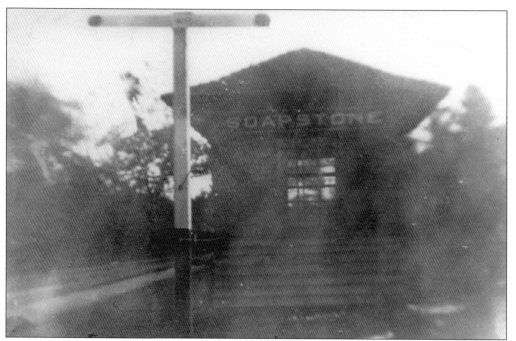

There were seven railroad stations on the "Rabbit Run," which extended from Athol to Springfield. Some say the name reflects the many stops and starts it made on the daily journey through the valley. This station in North Dana, known as Soapstone, was located near the soapstone mining operation to facilitate easy loading for shipment. Prescott and North Dana argued over ownership of this station. The railroad provided many jobs for residents.

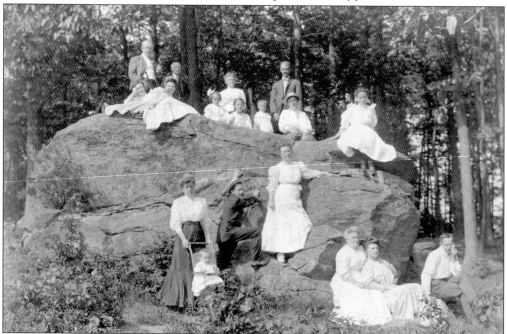

This huge rock was a perfect spot for this family group to pose for a picture as they gathered for a family reunion.

Three

BEAUTIFUL CHILDREN

All children are beautiful, and the Swift River Valley Historical Society collection provided many images to choose from. The intent was to create a sampler showing girls and boys of all ages and the style of clothing between 1750 and 1938. Sadly many of the pictures are unidentified. Help with identification from readers would be greatly appreciated.

Infants were clothed in long dainty dresses worn over petticoats of wool flannel. At bedtime they were put into nightgowns, wrapped in blankets, and put in cradles to sleep. This kept them warm because there was little room to move around. Cribs came much later.

Little boys wore dresses until they went to school and often still wore long hair in the early years of the 20th century. When they started school they usually wore knee pants and blouses, and in warm weather, bare feet. Little girls wore pinafores over plain dresses, black stockings, and high shoes. Large bows in the hair were popular. And of course, beneath it all, petticoats and bloomers were worn.

Families were proud of their children, and having many pictures preserved the memory of precious childhood.

This picture shows Warren Mahland and West Chilon, twin sons of Wales and Nancy Aldrich, born on October 29, 1847. They spent their entire lives in Prescott.

Margaret Brown of Dana looks ready for an Easter parade with her hat tied securely under her chin.

An unidentified mother and child pose for a picture. Baby dresses were very long and elaborately decorated with ruffles, ribbon, lace, and embroidery. The petticoat beneath would be made of fine woolen flannel and was equally elaborate.

Brothers, twins, cousins, or just friends? They appear very serious about having their picture taken.

What could be more angelic than the face on this little girl? The bonnet appears to be made of velvet ribbon and tied under her chin with a huge bow. The matching fur muff and neck piece complete the outfit.

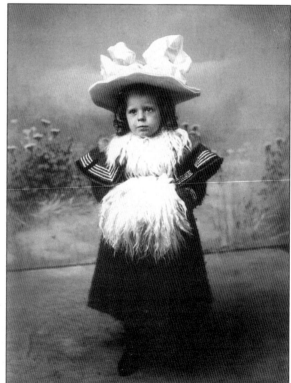

The same fur neck piece and muff appear on this little girl as in the previous picture. Are the girls sisters or are the fur pieces studio props? The backdrop was in the Harwood Photographic studio in Enfield.

This unidentified little boy may have just had his first haircut. His shiny shoes are probably made with no distinction of left or right to allow for wearing out evenly.

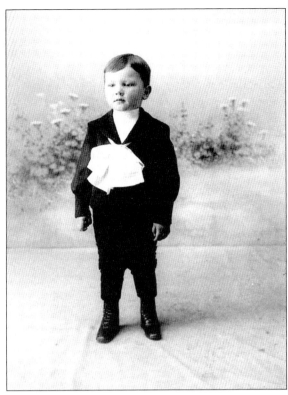

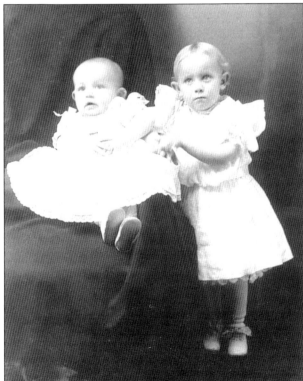

Ruffles and lace adorn the outfits of this little pair. The Swift River Valley Historical Society has many beautiful articles of baby clothes. The material is very fine, and the sewing is meticulous, much of it done by hand.

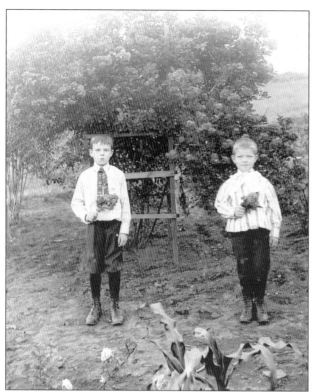

These little boys are dressed up for some special occasion. The one on the left wears knickers; the younger one wears knee pants. Their shoes appear well worn. The bush behind them is a rose bush.

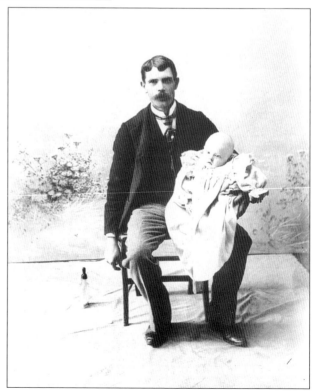

The baby inside all that fancy dress probably weighs less than 12 pounds! The father seems to be wondering if he can reach the bottle on the floor before the baby starts crying.

This picture is marked "Katie ages 3 and 1." Which one is Katie? Note the much-worn shoes on the older child and her elaborate crocheted collar.

This child with the "curl in the middle of her forehead" is wearing the same dress as the younger child in the preceding photograph.

Having the children's picture taken was important years ago and still is today. This unidentified pair posed for their formal portrait. It would make a wonderful gift for grandparents.

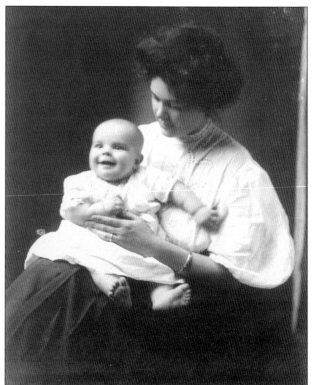

A mother poses with a very happy baby. This picture was probably taken after 1900 since the long baby dress was replaced with more comfortable and convenient clothing.

This little girl has had the hair around her face crimped with a curling iron. The lace bib is worn over the dress as a decoration.

This little girl seems to be saying "look Mom, I brought you a bouquet." This picture was probably taken in the late 1920s.

This baby is wearing a very elaborate dress with rows and rows of tucks and eyelet trim.

This brother and sister picture was found in a very old Greenwich collection. No identification was found.

These children are Earl and Ola Miller of Greenwich Village. Earl wears knee pants, and Ola is wearing high button shoes and holding a small bouquet. This pose is typical of Greenwich photographer Burt Brooks.

This little boy wears a hand-knit hat, coat, and leggings, along with an irresistible smile.

These children are unidentified. This posed picture challenges the imagination. Perhaps they are waiting for Santa Claus.

This little boy is on his way to school, carrying his lunch pail. He wears knee pants and a jacket. Note his long curls. This is a typical pose of photographer Burt Brooks of Greenwich.

This young man identified as Wallace Woods, age 11, wears two pins on his lapel, probably for school or Sunday school achievements. His style of suit and tie were worn after 1930.

This little boy is Raymond Chandler Davis, 23 months old. The picture was taken in 1900. He stands on a "corner chair."

This is a picture of Donald R. Moore, six months old, and his brother Harold E. Moore, three and a half years old. Harold has a boy's haircut, but will be wearing dresses until he goes to school.

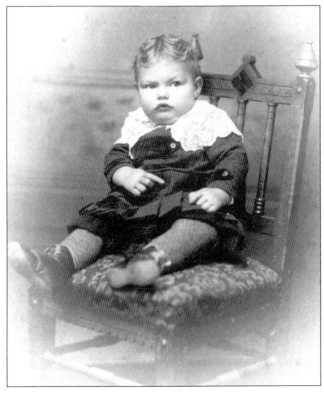

This little boy has no identification, but he certainly belongs in this chapter with beautiful children.

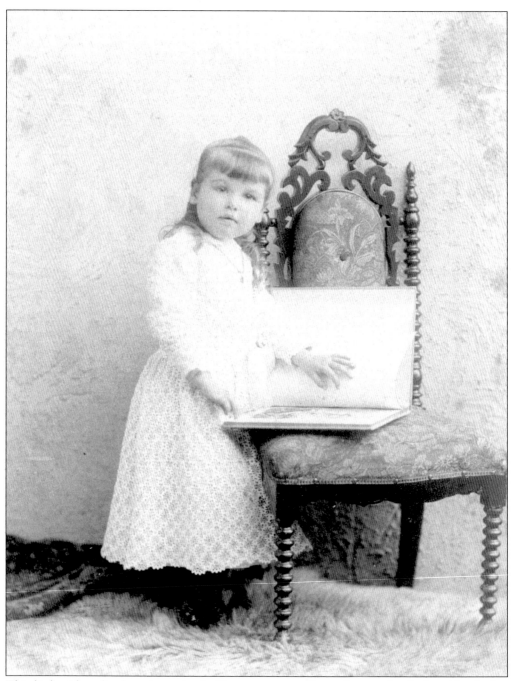

This little girl studies her picture book. She wears a very fancy dress and a chain with a locket around her neck. The chair was called a parlor chair and was seldom sat on.

This little girl poses with her very elaborately dressed doll. The doll probably has a painted tin or porcelain head and a cloth body. This would be a doll to look at rather than play with. The child is also elaborately dressed.

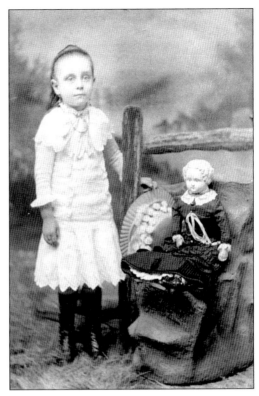

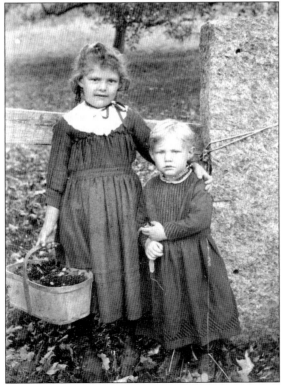

This little girl and her brother are "gathering." Some little boys had their hair cut long before they stopped wearing dresses. Both children are wearing high button shoes.

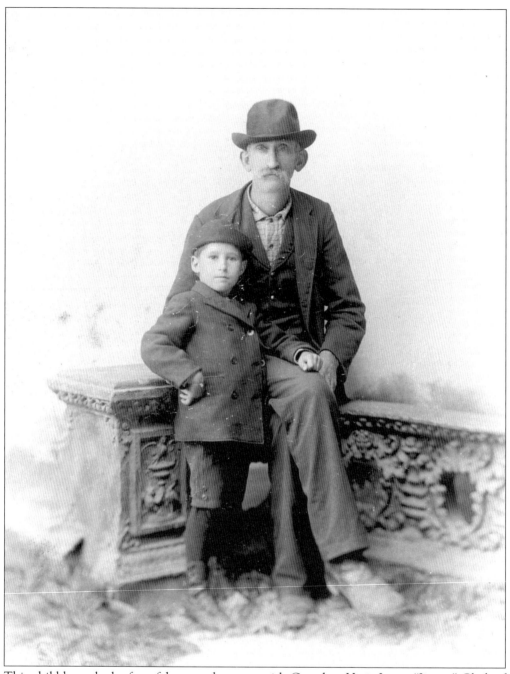

This child has a look of confidence as he poses with Grandpa. He is James "Jimmy" Clark of Greenwich, born on February 18, 1888.

Four

EARNING A LIVING

It is safe to say that most people in the Quabbin Valley never had pockets jingling with money. It is also safe to say they usually had enough to get by on. If things were really bad, friends and relatives were always willing to help out in whatever way they could. There were, however, many job opportunities available, and these people were not afraid of work. Farms, orchards, berry fields, and gardens provided many Prescott and Greenwich folks with a livelihood.

Dana and Enfield had many small factories and shops by 1850. There were gristmills, sawmills, cloth mills, the Box Shop, and the Hat Shop. There were small businesses where nails, pails, pots and pans, brooms, harnesses, saddles, buttons, shoe pegs, piano legs, matches, wagons, and wheels were made. There were teachers, preachers, doctors, policemen, firemen, and railroad workers.

The photographs and stories will give the reader a glimpse of some of the ways in which these people "brought home the bacon."

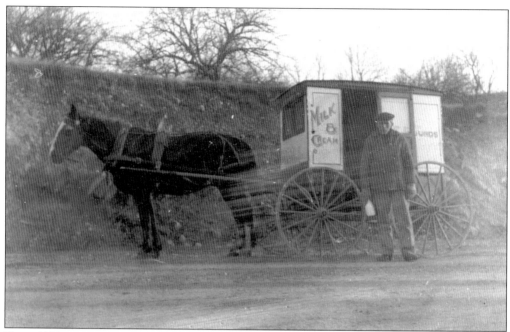

From 1850 to 1920, milk was delivered to your door, unless of course you had a cow. Before trucks, the milk wagon was a familiar sight. The horse knew the route as well as the driver, and in this picture he waits while the milkman brings a quart of milk to the door. An apple orchard is visible in the background.

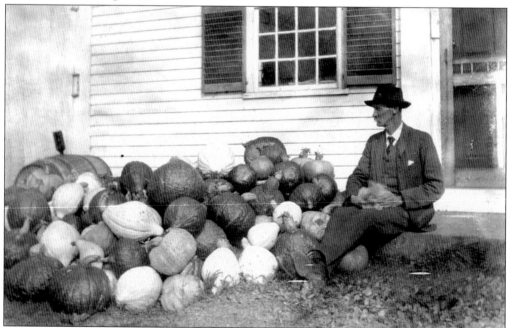

Farmers raised crops large enough to sell and to provide for the family as well. Anyone would be proud of this yield of winter squashes. Farmers kept meticulous journals recording the kind of seeds planted, the seed company, the quantity and cost of the seeds, and the results, which were used in planning the next year's crop.

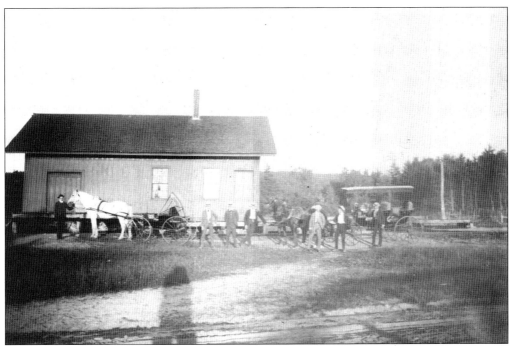

This group is waiting for the train to arrive at the station. The horse-drawn "cabs" are waiting to transport passengers, mail, or supplies. There are very few pictures of surreys at the Swift River Valley Historical Society. A surrey is a wheeled wagon with a flat top and seating for several passengers.

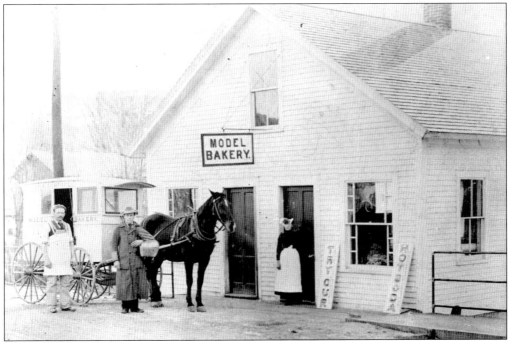

This is the Model Bakery in Enfield, owned by Herbert Campbell, the gentleman in the apron. The sign says "Try our hot soda." (Courtesy of Linda Hanscom.)

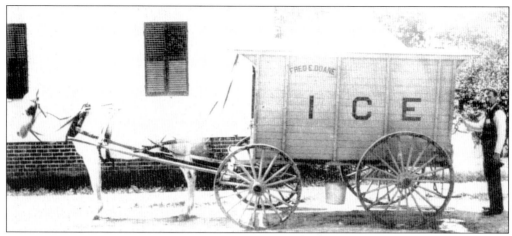

Before electricity, every household had an icebox or ice chest. The top section opened upward and was lined with zinc. The ice cake was placed here. Below was a door opening outward. Food was kept in this section. The iceman supplied cakes of ice with frequent deliveries. He wore a rubber apron over his shoulders and would pick up the cake of ice with ice tongs, swing it onto his back, deliver it to the house, and place it into the chest. The horse waited patiently.

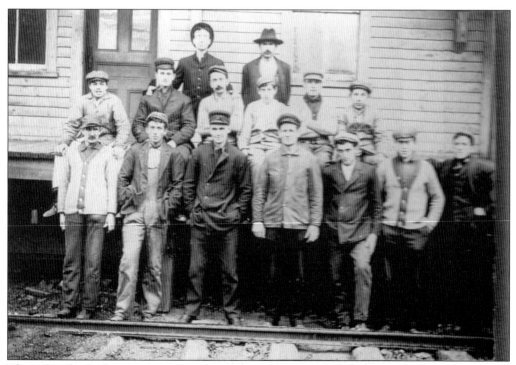

The railroad, which extended the length of the valley, provided a variety of jobs. There was the stationmaster, the freight house crew, and laborers who kept the tracks clear of obstacles and in repair. This included snow removal in the winter.

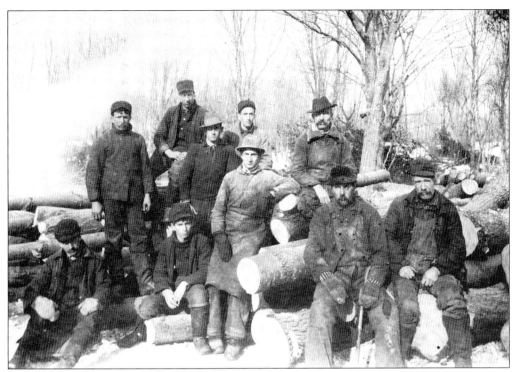

Many men were employed as loggers in the sawmills. Surrounded by piles of logs, these men stop for a picture. The man in front is holding a cant hook. This is an iron hook on a wooden handle, which is used to tilt, pitch, or turn the logs over. Logging was dangerous work, and many tragic accidents happened.

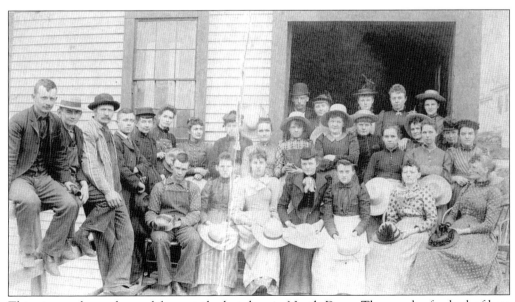

This picture shows the workforce at the hat shop in North Dana. Thousands of palm-leaf hats were produced here and shipped all over the world.

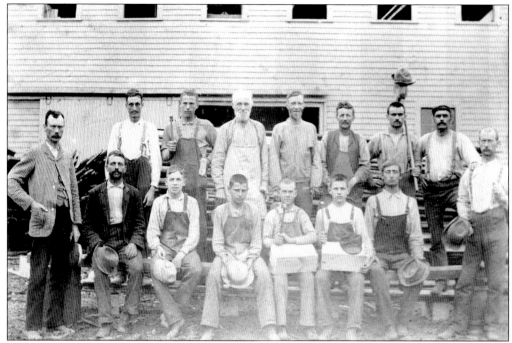

This group of workers is employed at the Box Shop in North Dana. They are posed in front of a huge pile of boards, the raw material. Two men in the front row hold the finished product. The man in the back row with his hat on a broom handle has a sense of humor, but no smile.

This is Rev. F. H. Wheeler and his family. He is seated in a corner chair, a piece of furniture with a square seat and only one arm. It could fit neatly in a corner if more floor space was needed.

This lady is Abbie Thompson, a longtime organist at the Methodist Church in North Dana. The picture is dated 1912.

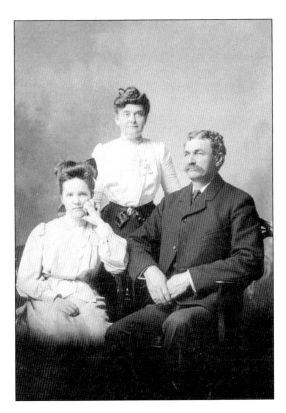

This picture shows Henry Goodman, his wife Jennie, and his daughter Hazel. Henry was born in Prescott and became a very successful businessman as co-owner of the Hat Shop in North Dana. He kept a stable of racing horses that were trained on his own half-mile track. His most famous horse was known as Belle G.

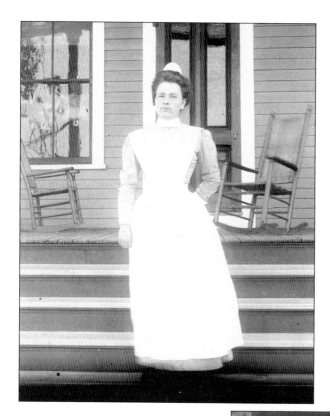

The identity of this nurse is not known, but she is in the employ of someone needing care.

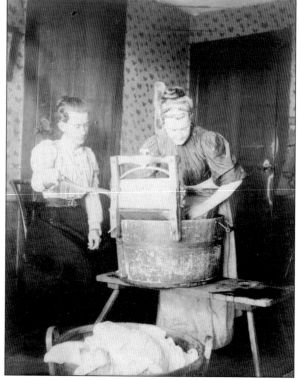

Taking in washing was a way for women to earn a little money. White clothing was boiled in a copper boiler over a wood fire and then scrubbed on a washboard with homemade soap. Dark clothing was scrubbed the same way. The wash was then rinsed and put through a hand wringer, shown here, and after drying, it was ironed with a "sad" iron on a padded wooden ironing board, folded, and returned to the owner.

This man is splitting logs on the riverbank near the mills in North Dana. Manpower was the only available equipment.

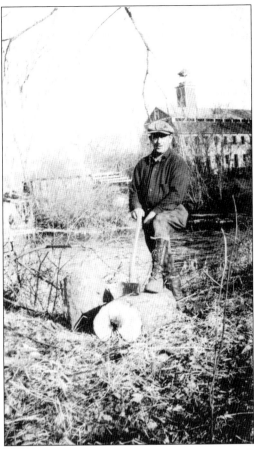

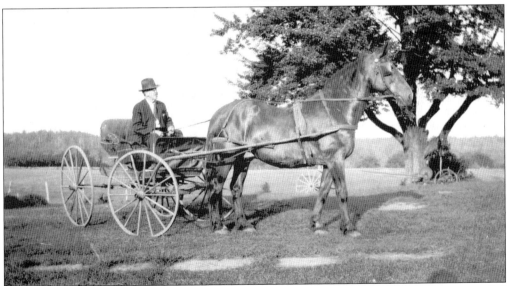

Dr. Myron Chapin was a horse-and-buggy veterinarian. Cows and horses sometimes needed medical attention the same as people. An old newspaper clipping recounts a home invasion in which the good doctor was tied up and robbed of $90 and 100 chickens.

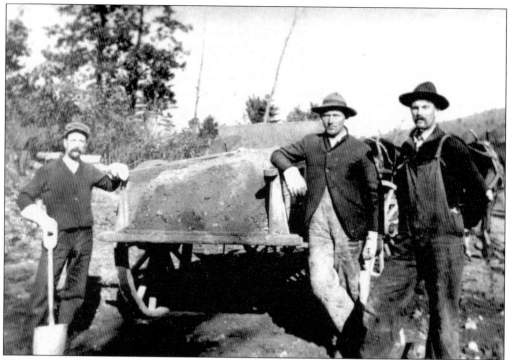

This picture shows the Greenwich "road gang" with a tip cart. They are filling holes in the road. From left to right are Willis King, Ed Randall, and John James.

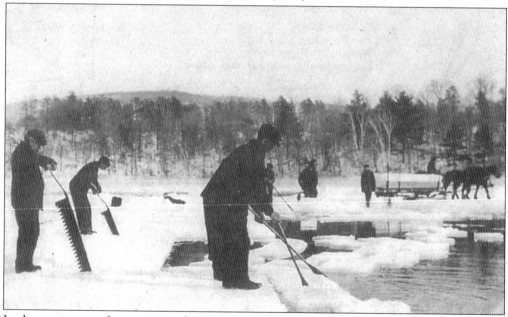

Ice harvesting was done on many lakes and ponds. Greenwich Lake provided many tons. This picture shows the work in progress. The ice is first marked into cakes, then cut with a long ice saw, pushed away with pike poles, loaded onto horse-drawn sledges, and hauled to icehouses or loaded onto the train to be shipped to cities. It was cold, dangerous work with many tragic accidents. A saw, similar to the ones seen here, is on display at the Swift River Valley Historical Society.

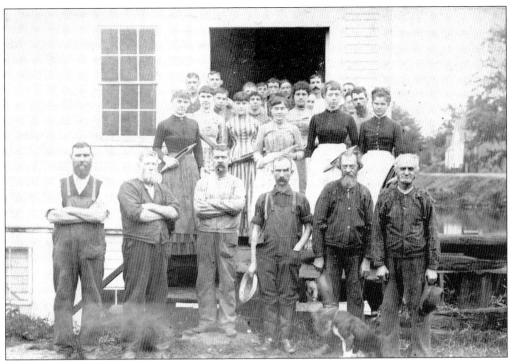

This picture shows the workforce at the Crawford and Tyler Mills in North Dana. Some of the ladies are holding the bobbins used in the manufacture of cloth.

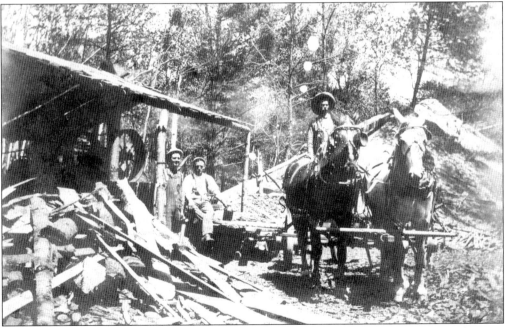

This sawmill is one of many in the Quabbin Valley. A pile of slabs from the process of sawing the trees into flat boards is seen on the left. The sawdust was blown onto the pile seen in back of the team of horses. This by-product was used to bank houses as protection against the cold, as for bedding for animals, and in icehouses to keep the ice frozen.

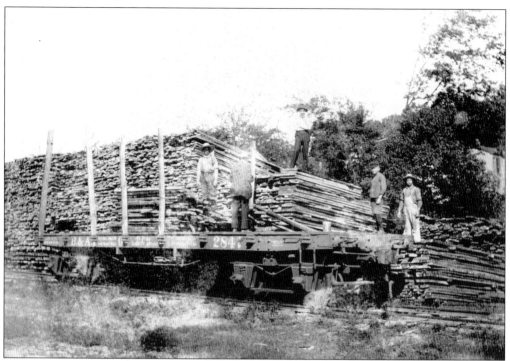

A huge pile of boards is being loaded onto a railroad flatbed for shipment. There was no heavy equipment available to assist them.

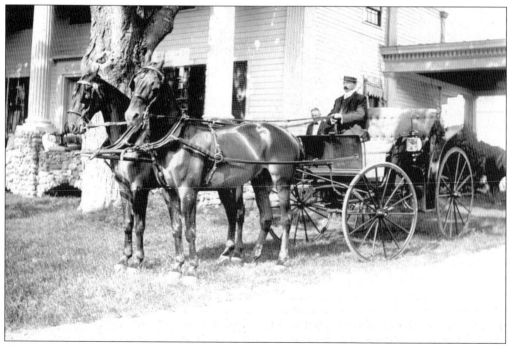

This picture shows a fancy pair of driving horses and an equally fancy buggy complete with a lantern on the side. The driver is in the employ of the Powers family.

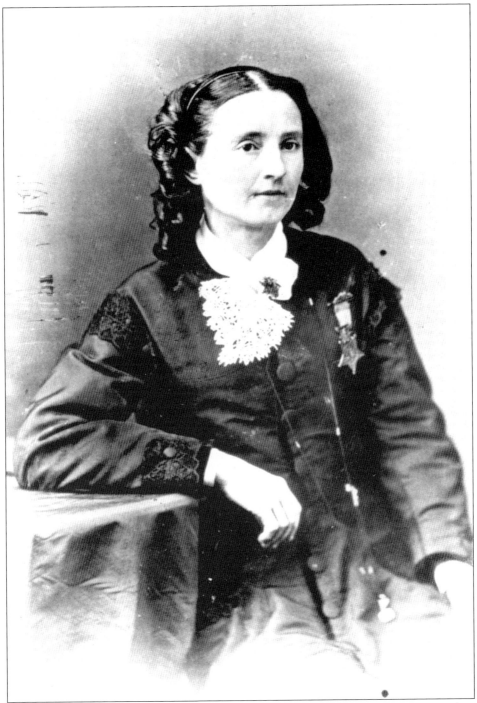

This picture shows Dr. Mary Walker, who was nationally known as the first woman in history to serve her country on the battlefields of the Civil War as assistant army surgeon, with the rank of lieutenant. She was the first woman physician to be taken prisoner of war and was later exchanged for a man of equal rank. At the end of the war, she was awarded the Congressional Medal of Honor that she wears in this picture.

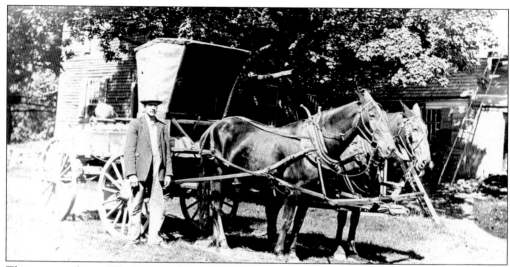

This picture shows Ellis Pierce, who was the cream gatherer in Prescott for many years. He used the wagon that formerly was used by Levi Newton of New Salem.

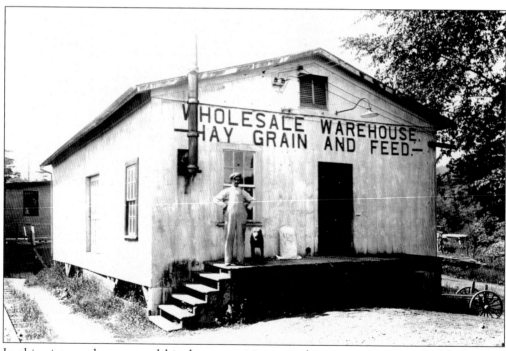

In this picture, the man and his dog are waiting to welcome customers to the "feed store." Farmers could buy grain and other supplies for cows, horses, and chickens. They could also sit by the stove (note the stove pipe) and get the latest news.

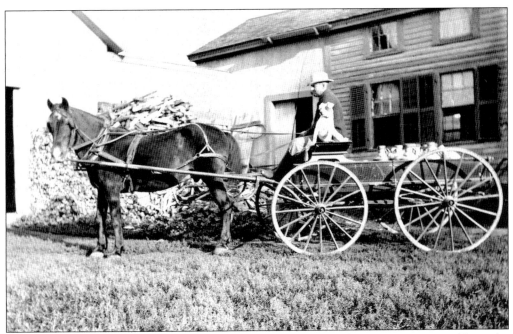

This man and his dog are gathering cream from local farmers. The 10-quart cans, visible in the back of the wagon, will be taken to the creamery where the contents will be made into butter and sold.

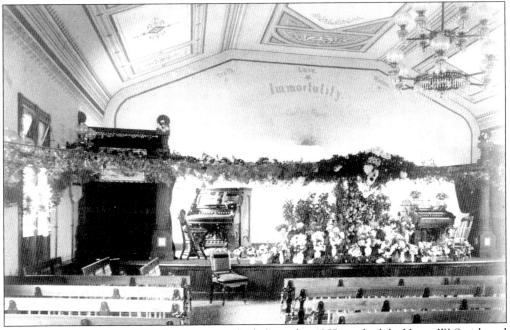

The Independent Liberal Church in Greenwich, dedicated in 1855, was built by Henry W. Smith and torn down by him in 1902 following a stormy existence. Smith, a man of means, became interested in spiritualism and eventually lost everything by trying to force his beliefs on others. This picture shows the interior of the church as it was decorated for the wedding of his daughter, Carrie.

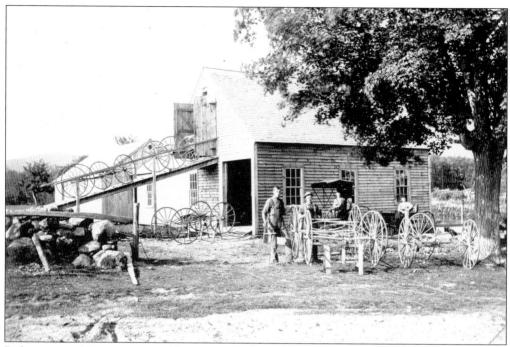

Before automobiles, wagons and buggies were the only mode of transportation. The roads were rough, and wagon wheels had to be repaired or replaced frequently. This shop in Greenwich was owned by Frank Anderson and appears to have customers waiting.

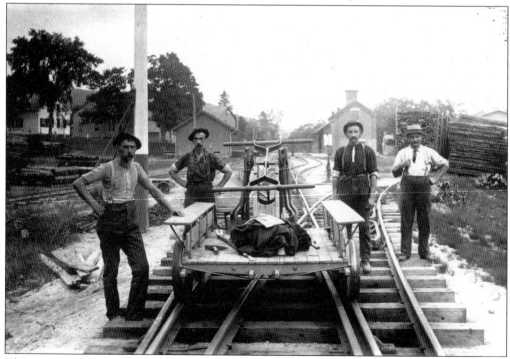

This picture shows a railroad crew with their handcart. The cart was propelled down the tracks while the crew checked the condition of the rails and rail beds.

Five

ANIMAL FRIENDS
AND HELPERS

The remark "If it doesn't lay eggs or give milk, we can't afford to feed it" was often heard, particularly when a child begged for a puppy or kitten. There were holes in this line of reasoning, however. The strong bond between humans and animals is evident in the photographs chosen for this chapter.

The hunting dog was an important partner for the hunter. Cats were needed to keep rats and mice out of the corn crib and granaries. A cow was essential to every family if there was to be milk, cream, and butter on the table. A driving horse was necessary to pull the buggy. Before automobiles, it was the only form of transportation. The workhorses and oxen were needed for the heavy work around the farm.

When the animals carried out their duties, they certainly deserved a kindly pat. How could anyone not feel affection for his animals when he looked into their big soft eyes?

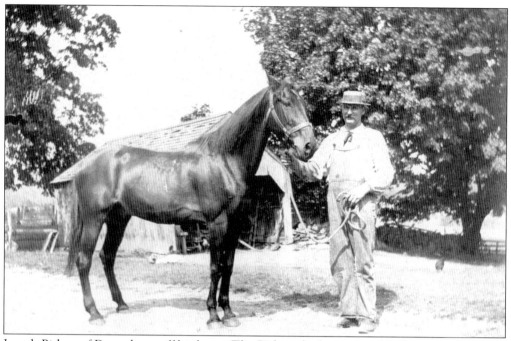

Joseph Bishop of Dana shows off his horse. The Bishops had a pet cat also. It was named James and was often dressed in a red suit and hat with a feather. He sat at the family table and ate with meticulous manners. He always accompanied Bishop to the barn at milking time.

On the back of this picture is written "1924 to Grandpa from Raymond." No further identification is found. What a happy pair! The saddle belongs on a much larger horse. Raymond holds tightly to the horn.

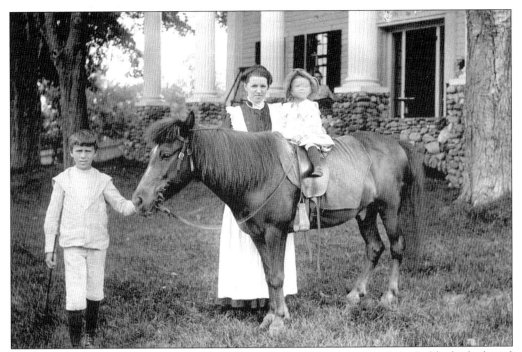

The Powers family was among the more affluent in Enfield. The nanny here holds the little girl on the pony while big brother holds the pony. The saddle, however, fits neither the child nor the pony.

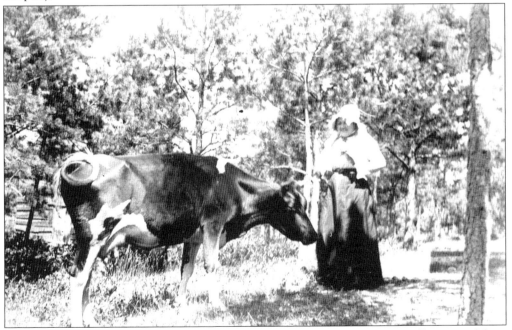

This lady and her cow are enjoying a moment in the sunshine. The lady is well protected from the sun. The family cow was most often a Jersey or Guernsey breed known for their rich milk. This provided milk to drink and cream for butter. Today there are many Holsteins known for the quantity of milk and not their butter-fat content.

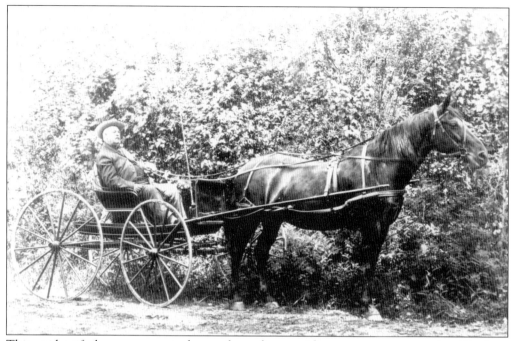

This unidentified man appears to be out for a pleasure ride on a warm summer day. The long whip in the holder could be easily reached should he need to get the attention of the horse.

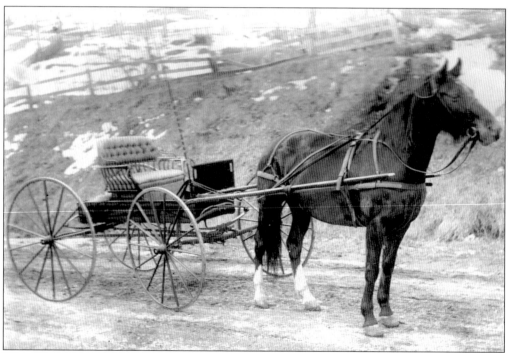

Where is the driver? This horse has a "blaze" on his forehead and white stockings on his hind feet. Black hoofs were considered stronger by blacksmiths. The wheels on the buggy were probably made in the buggy wheel shop in Greenwich.

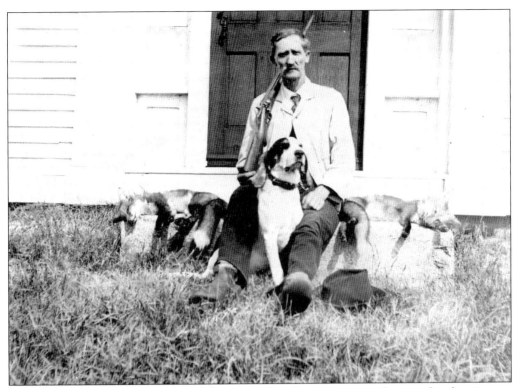

The sale of furs and bounties paid by towns for destroying animals considered nuisances was a source of income for some. Howard Vaughn, shown here with his dog and a few fox carcasses, was an avid hunter, as evidenced by many pictures in the Swift River Valley Historical Society collection.

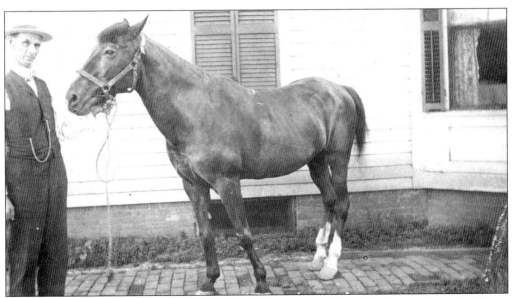

In this picture, Henry Tolman holds Old Pink for a picture. Note the short tail on the horse. Horses are not born with bobtails.

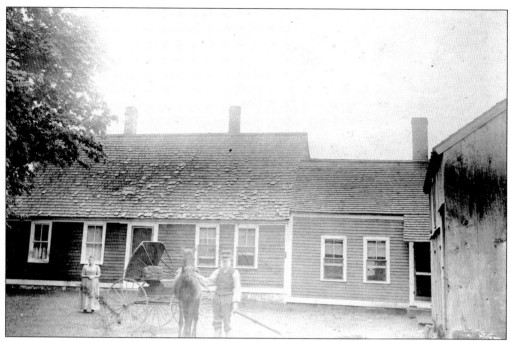

A man and his horse are the subject of many pictures in the Swift River Valley Historical Society collection. Usually family members are a part of the picture too, as in this one.

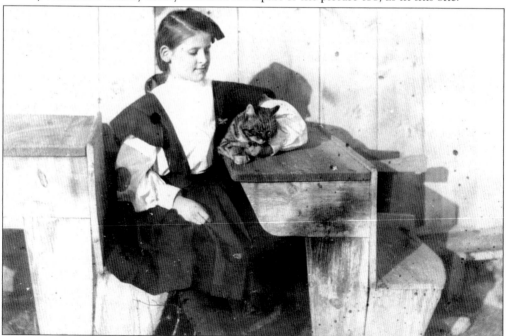

Cats were not the house pets of today, but were kept around to take care of rats and mice that would eat the corn and grain. These were known as barn cats and were pretty much left to their own devices for survival, but there were exceptions, as this picture shows. The crudely constructed desk-chair combination must have come from a very early schoolhouse, which probably had been abandoned.

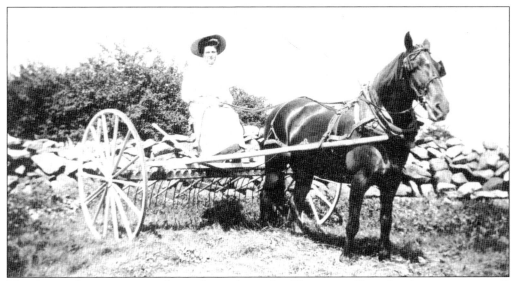

This piece of equipment is a horse-drawn hay rake. They are still used today on many small farms. This was considered light work and was assigned to women. The horse is wearing blinders to keep his attention focused on the job at hand. Note the rocks that were thrown from the fields to clear the land and used to create a wall.

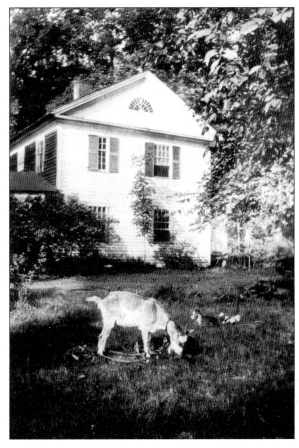

This goat is Flossie. The date is 1913. Goats were sometimes used to pull children in a small cart. They were also useful to keep grass and brush at a minimum. The female goat, known as a nanny, gave rich digestible milk.

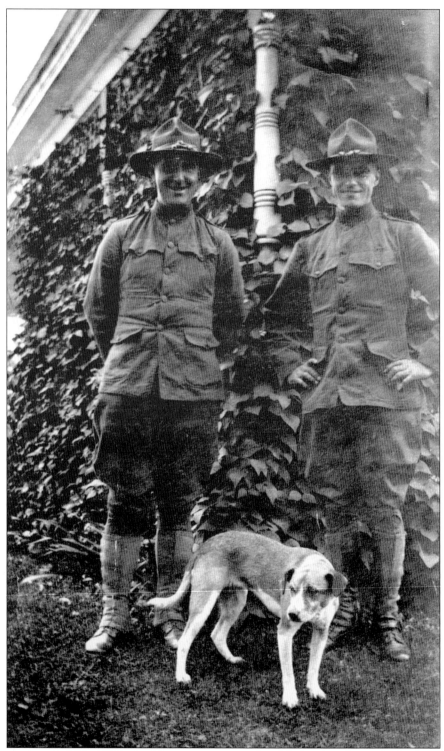

These unidentified World War I soldiers are enjoying a brief furlough at home. Is the dog worried about them leaving again?

Six

HATS, HAIR, AND MUSTACHES

The expression "crowning glory" will take on a new meaning as the reader enjoys the images in this chapter. Mustaches (preferred spelling) or moustaches seem to have come in all sizes, shapes, and colors. Some were well groomed, and others appear to just grow.

Mustaches and manliness walked hand in hand in the Victorian years. They were groomed in many styles and secured at the tips with wax. Unfortunately, a hot drink would melt the wax. The problem was solved in 1837 when an Englishman named Harvey Adams invented the mustache cup. A ledge or guard was molded across the top of the cup. Later there were clip-on lips that could be carried in the pocket and put on a cup as needed. Mustache cups were made for right or left handed people. The mustache cup is now a collector's item.

During World War II, some U.S. soldiers grew and groomed handlebar mustaches to make themselves indistinguishable from the German enemy. Mustaches and beards are still popular. Today some men use a glue stick to keep the hair in place.

Ladies always wore hats, and there were hats for all occasions. For those wanting to design their own hats, patterns could be purchased or one could go to the milliners shop and have a hat custom designed.

If the lady was not blessed with natural curls, crimping was done with a curling iron heated over a kerosene lamp. The curling iron opened like scissors. The hair was wound around the rod and held by the other piece until the hair was curled. Short hair for a lady was not fashionable until the early 1900s.

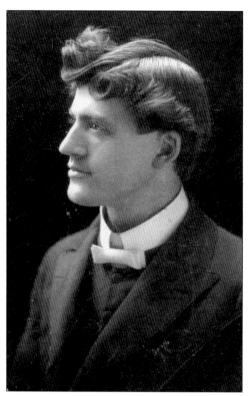

This handsome young minister, J. Alexander Betcher, must have caught the attention of the young ladies in Prescott. He was minister of the Methodist church. The church is now part of the Swift River Valley Historical Society in North New Salem. While he was minister in 1903, the singers' gallery was removed, 11 stained-glass memorial windows were installed, and two front doors were replaced with one door. Reverend Betcher's name is over the front door.

This young lady has a carefully groomed hairdo with the top in waves created with a curling iron. An ornament called a comb adorns the back at the top of her head. The combs had teeth and were made of bone, tortoise shell, or celluloid.

This is Harriet N. Oaks (née Paige). On the back of the picture was written, "wearing 150 braids of her own hair which took two or three days to do." There were uses for hair no longer attached to the head. It was often painstakingly braided or woven to resemble flowers and placed in a frame. Mothers clipped snips of baby hair, tied a blue bow for a boy and pink for a girl, and tucked it away in a baby book.

This unidentified woman is wearing a hat with a curved brim. The large black plume above the brim is probably an ostrich feather. A small fabric flower is tucked neatly into the curve below.

This lady poses with a slight smile and a twinkle in her eye. Covering her graying hair is a hat of feathers and ribbon tied securely beneath her chin. Her shoulder caplets are decorated with beading. Everyone dressed in their very best for special occasions.

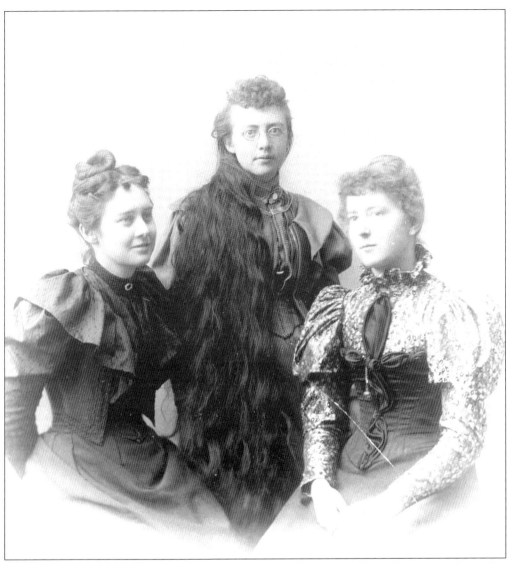

This is a picture of three Graces—Grace Powers, Grace Oakes, and Grace Haskins, in that order. Grace Haskins was the daughter of Edwin Haskins and Mary Anette Haskins (née Whitaker). She served as librarian in North Dana for many years. Grace Oakes of North Dana moved to Florida with her parents in 1872. She was four years old at the time. Her mother contracted yellow fever, and unable to care for Grace, she was sent alone by train back to North Dana to be cared for by her grandmother. Soon her mother died, and Grace remained in North Dana for the rest of her life. Grace Powers was the daughter of Orrin Powers and Ellen Powers (née Albee).

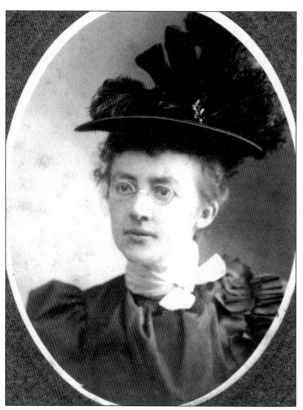

Here is another picture of Grace Oakes wearing an ornate hat of velvet and feathers. Her long hair has been cut.

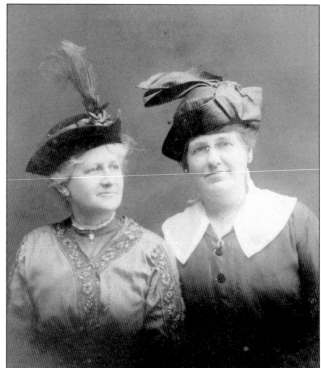

The style of hats for older ladies was a little more sedate. They fit the head snugly, but the ornamentation added height. These hats are made of straw.

A large feather plume adorns this young lady's hat. She is wearing a gold bangle bracelet, popular in the late 1800s and still fashionable today.

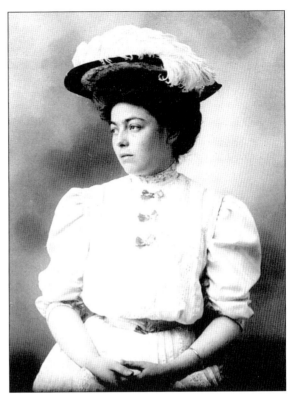

This bouffant hairdo is secured at the back with a large bow. The young lady is identified as Marietta Powers of Prescott.

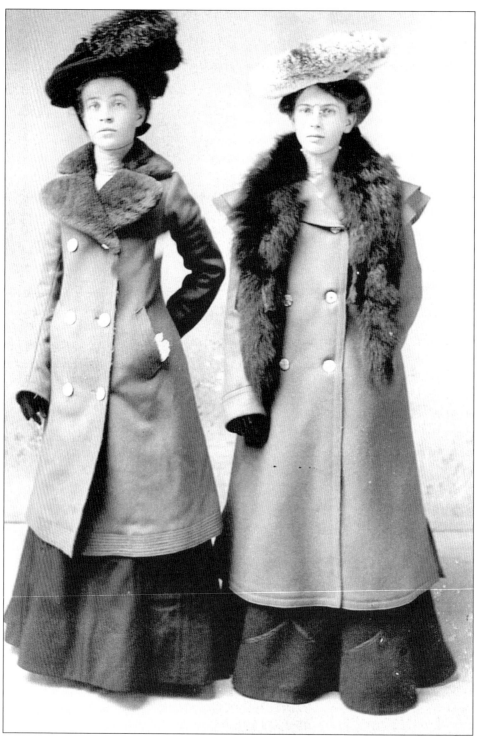

These ladies model winter coats and velvet hats. The material for the coats could have been woven in the North Dana woolen mills. The buttons could have been made in North Dana, and the fox fur (on the lady at the right) could have been trapped locally.

This unidentified young lady displays a very lovely head of hair. She is also wearing the very stylish gold bangle bracelet.

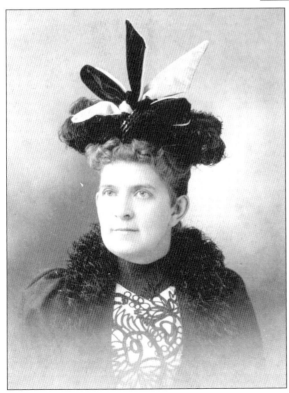

This lady is wearing a carefully designed outfit. The bow of velvet and satin on her hat gives added height.

This picture shows Nathaniel Lafayette with a neatly trimmed mustache and beard.

This neatly dressed man wears short sideburns and a handlebar mustache. His identity is unknown. The pin on his tie is a stickpin.

This lovely young lady is probably dressed for a lawn party. Her hat is held on with long hat pins, and her hair is secured at the back of her neck with a huge bow.

In this picture, a young Fred Miller of Greenwich Village appears very proud of his tiny mustache—a sign of maturity.

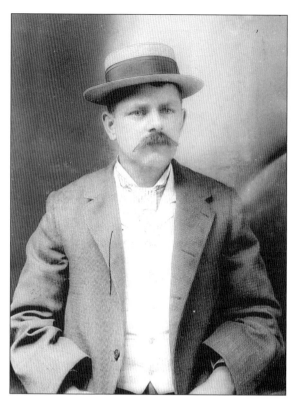

This gentleman has a handlebar mustache with no waxing on the ends. His straw hat was probably made in the North Dana Hat Shop.

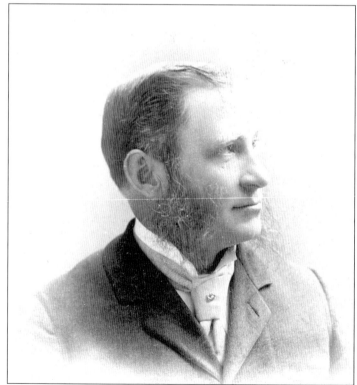

This man has sideburns only. He also has a stickpin on his tie. He is identified as Arthur J. N. Ward, born in Enfield in 1849.

A mustache cup would be a necessity for this unidentified man.

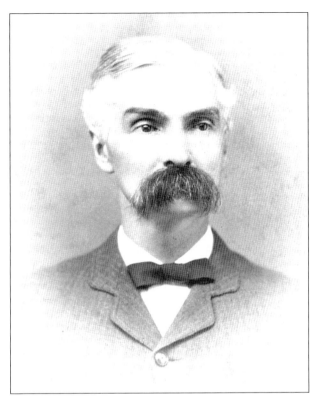

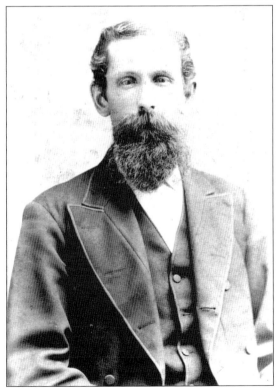

This unidentified man has a full mustache and beard. His suit jacket has button holes on both the right and left side of his coat.

This gentleman has a full beard. He is wearing a fancy white vest and gold watch chain. The watch was tucked into his vest pocket.

Six

SCHOOLS AND
SCHOOLCHILDREN

Laws pertaining to schools and education were already in place when the Quabbin Valley was settled. In 1642, Massachusetts law ordered that every town with over 50 families establish an elementary school, and in 1852, the compulsory school attendance law was passed. At this time, the Massachusetts School Register, a legal document recording attendance, was required for every school.

The one-room school with pupils of varying ages required cooperation, with older ones helping younger ones. Good behavior was expected, and punishment was swift and severe. School committee members (men only until 1891) were elected officials in charge of hiring teachers and holding their feet to the fire. A "perfect" teacher was one who could maintain discipline and was so evaluated. Later Enfield, Dana, and Greenwich had consolidated schools while Prescott had several one-room schools because of the geographical spread. In 1878, there were 100 pupils in Prescott schools, and although parents supported education, three truant officers were required.

School days were happy days despite it all. The custom of taking school pictures each year has carried on to the present times. This chapter shows many school groups on that special picture day, along with many of the school buildings. The Swift River Valley Historical Society welcomes any and all memoirs and identification of people and places.

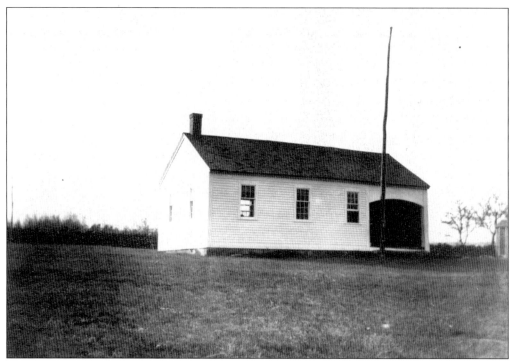

The No. 1 school in Atkinson Hollow in Prescott was abandoned before 1920 due to the lack of students in the neighborhood. The building in this picture replaced a much earlier one in the same place that had been destroyed by fire in 1820. The foundation stones remain today.

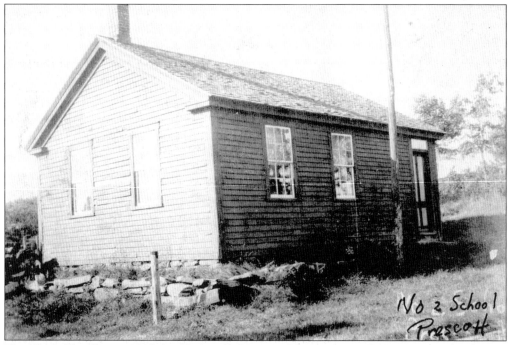

The No. 2 schoolhouse was located near the Herman Powers place. The one-room schools were all of similar size and design.

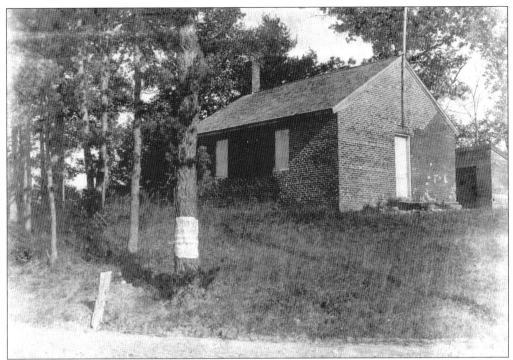

This school of brick was known as the red schoolhouse in Dana. The outhouse can be seen at the far right. Among students attending this school were Henry Tolman and Roger Vorce. An auction bill is posted on the tree.

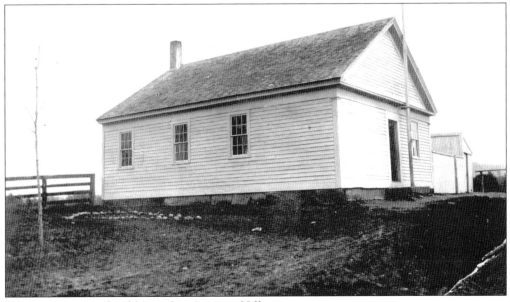

This is the No. 3 school located on Prescott Hill.

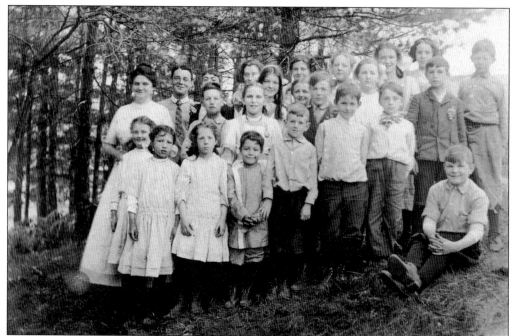

This is the student body at the Greenwich Village School in 1912. The students are Helen Bekovski, Mary Bekovski, Edwin Lego, Herman King, Austin King, Oliver Jones, Lucy Jane Jacobs, Howard White, Alice Randall, Eva Lego, Dorothy Hall, Stanwood King, Viola Moore, Stanley Wheeler, Fred Lego, Bob Beals, and Raymond Lego. Raymond King is the teacher.

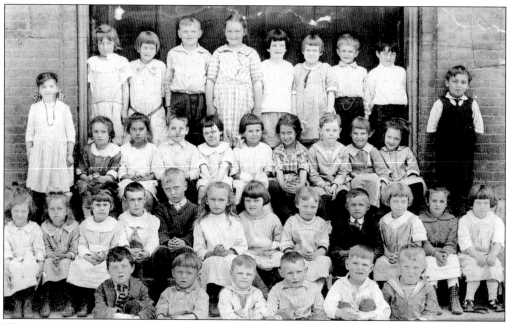

This Enfield group picture was taken in 1923. They posed for this picture on the last day of school. There is no teacher in this picture.

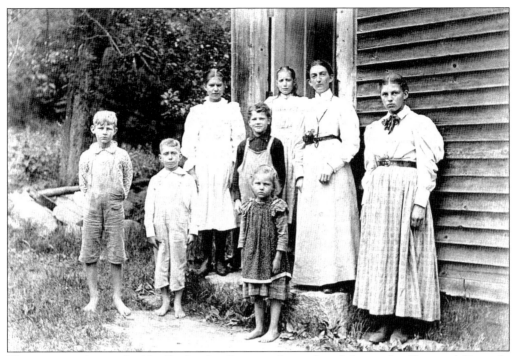

This picture taken at the No. 5 school in Prescott shows, from left to right, (first row) Oscar A. Stacy, Merle R. Brown, and Minnie E. Brown; (second row) Bernice S. Stacy, Ernest Cashing, Floy E. Brown, Hattie Bliss (teacher), and Annis Stacy.

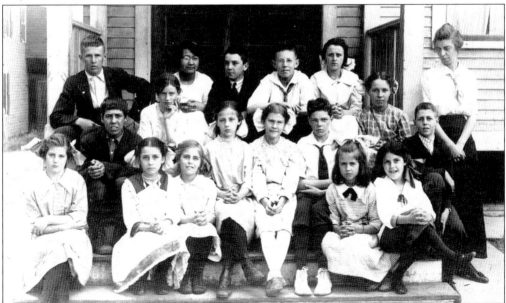

This picture shows the children at the North Dana Grammar School in 1915. From left to right are (first row) Marie Lynch, Mary Bigelow, Mildred Schouler, Mildred Smith, and Helena Doubleday; (second row) George Boudreau, Florence Pratt, Anna Burke, Gladys Reed, Herman Lindsey, and Leon Dufresne; (third row) Donald Smith, Clementina Falavena, Paul Canuel, Harry Williams, and Rose Myatt. The teacher is Miss Marsh.

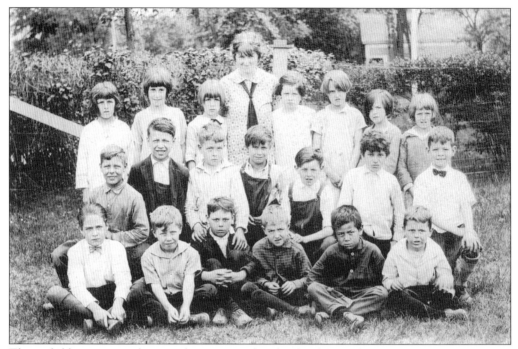

These children were students at the Greenwich School in 1925. Their teacher, fourth from the left in the back row, is Edith Martin. The Swift River Valley Historical Society has memoirs of Martin's school experiences in Greenwich, given by her daughter.

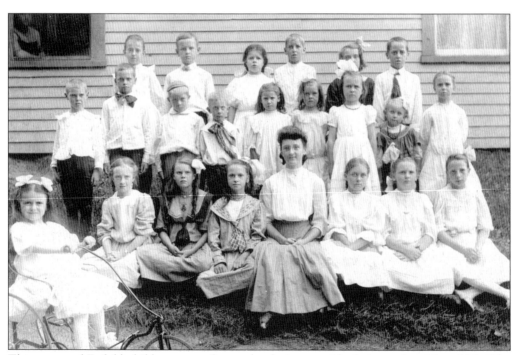

This group of Enfield children poses for a school picture with their teacher Mary Lisk. The children are not identified.

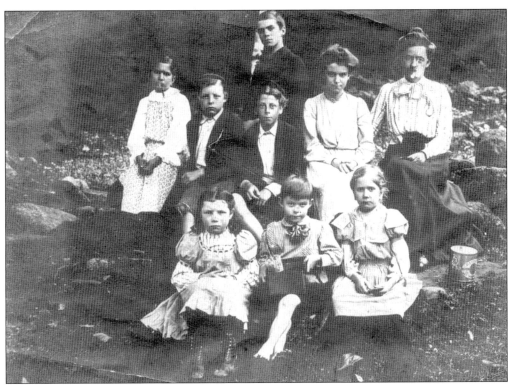

These children attended the so-called Under-hill school in Prescott. It was the No. 5 school. From left to right are (first row) Rose Lincoln, Clyde Powers, and Vera Brown; (second row) Gladys Brown, Conrad Lincoln, Arthur Day, and Leola Whitaker. Earl Whitaker is standing. The teacher is not identified. When this school was built, a neighbor wanted it to be red so he donated the paint.

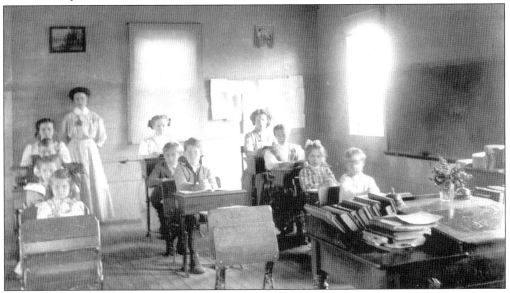

This is the interior of the Southworth Mills School in Greenwich. It appears to be a one-room school with a small group of students. It is a far cry from the classrooms of today.

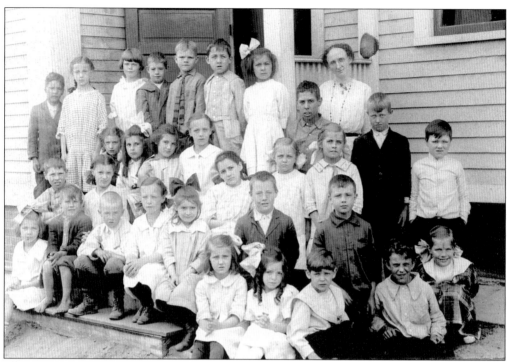

The top picture shows the first, second, and third primary grades in North Dana taken in 1914. The lower picture is of the same grades taken in 1916. The teacher, Emma Parker, is seen in both pictures. Being together for three years created a well-integrated group. Integrated classrooms are recognized as having educational value today. However, the recommended class size today in Massachusetts is under 20 students. Parker was responsible for 31 students.

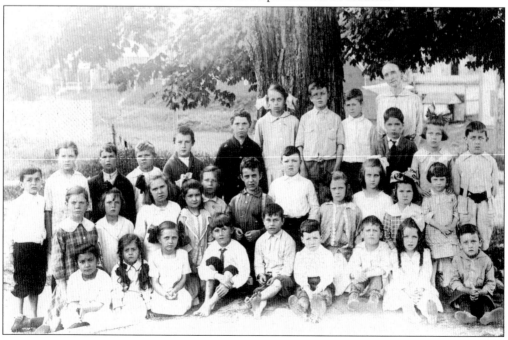

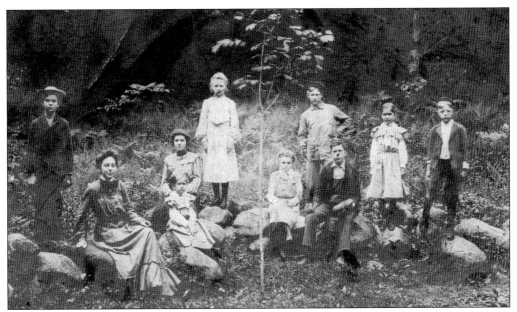

This group with their teacher found a nice spring day just too irresistible and has taken a nature walk.

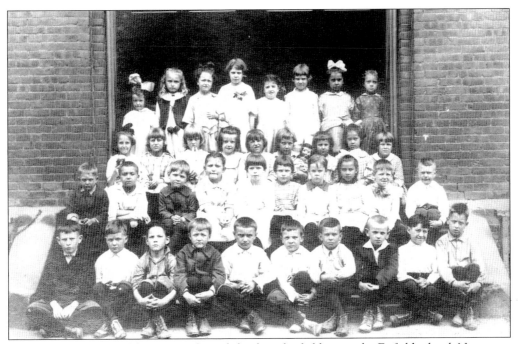

Here is another class of first-, second-, and third-grade children in the Enfield school. No names are known, and identification would be welcomed.

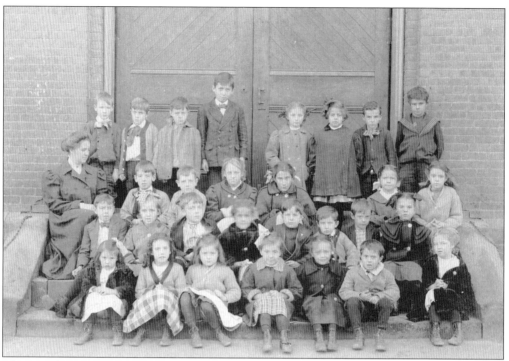

This was the second-grade class in Enfield in 1909. Mary Carmody is the teacher.

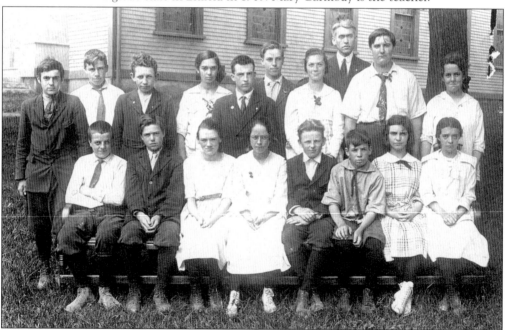

This is the grammar school graduating class of 1919 in Enfield. Not all are named, but the class included Earl Avery, Frank Ingraham, Lawrence Milsop, Emily Parsons, Roger Lannon, Wilfred Leuba, Lelia Dwight, Gayle Stevens, Beatrice Gibbins, Howard Bowen, Joseph Blakely, Emeline Burton, Beulah LaBelle, Stanley Bryans, Albert Hunt, Patricia Hegeman, and Charlotte Lannon.

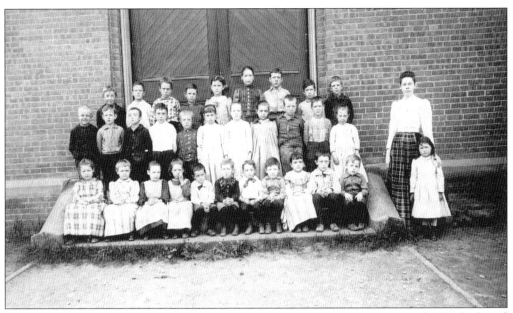

There are 32 unidentified students and their teacher at this school in Enfield. The little girl standing beside the teacher did not want to have her picture taken.

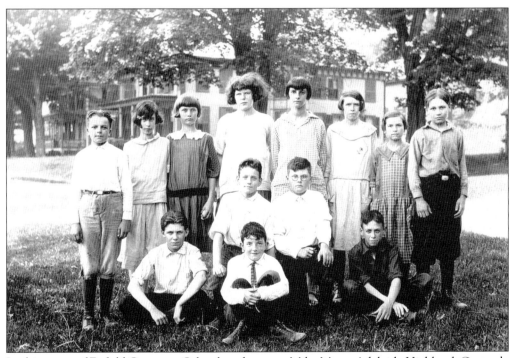

In this group of Enfield Grammar School students are Mike Mayo, Adelaide Hickland, Gertrude Ward, Muriel Downing, Ken Damon, Howard Hill, Charles Fargo, Maurice Rohan, and George Russell.

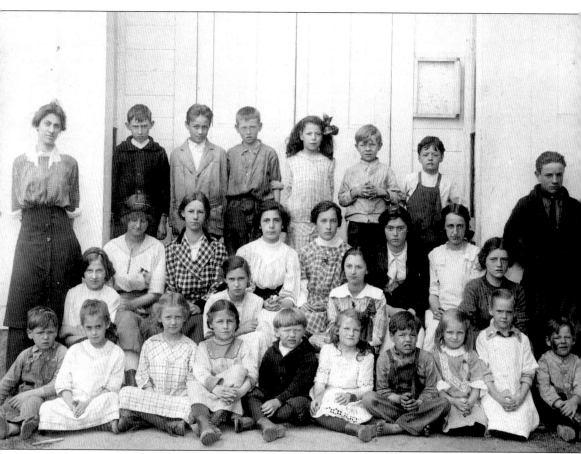

This group is the student body at the Dana Center School in 1913–1914. The teacher is Miss Sjoberg. From left to right are (first row) Philip White, Hazel Bates, Anna Almquist, Florence Eddy, Carl Almquist, Dorothy Eddy, Milton White, Gertrude Chalifoux, Ada Bates, and Linwood Ray; (second row) Mabel Ray, Ethel Bates, and Louise Hildebrand; (third row) Lilly Almquist, Pearl Cooley, Agnes Chalifoux, Ethel Smith, Marjorie Best, and Stella Blackmer; (fourth row) Forrest Blackmer, Duane White, Ernest Doane, Dorris White, Kenneth Ray, and James White.

Eight

FINAL MEMORIES

In all walks of life there are people with special talents. The towns of the Quabbin Valley were home to artists, authors, doctors, inventors, musicians, preachers, teachers, sculptors, and patriots. Many of their accomplishments and works are known.

Quabbin Valley People and Places would not be complete without mentioning Daniel Shays, the patriot from Prescott; Burt Brooks, photographer and painter from Greenwich; and Rufus Powers of Prescott, inventor and holder of many patents. There was Edward Potter of Greenwich, who along with Daniel French sculpted *Patience and Fortitude*, the lions who guard the entrance to the New York City Public Library; and James Madison Stone of North Dana, author of Civil War memoirs. There was Dr. Mary Walker of Greenwich, who received the Congressional Medal of Honor for her service on the battlefield during the Civil War; Benjamin Harwood, photographer from Enfield; Francis H. Underwood of Enfield, author of *Quabbin the Story of a Small Town*; Donald Howe, author of *Quabbin the Lost Valley*, which records all the details after the demise of the towns; Lillie Pierce Coolidge of Prescott, author of the *History of Prescott*; Olive Molt, painter of many pastels of the valley; Dr. Willard Segur, the country doctor; Rev. Hosea Ballou of North Dana, recognized as the father of Universalism; and Harold Brown of North Dana, known for his religious music.

Talented people continue to recreate the Quabbin Valley today. A talent shared is a gift for all time.

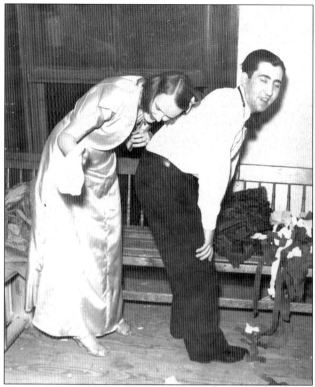

The Farewell Ball on April 28, 1938, observed the end of the towns of Dana, Enfield, Greenwich, and Prescott at the stroke of midnight. Even this sad evening was not without its lighter moments. This picture shows Al Ritchie, saxophone player in the orchestra, after he accidentally sat on a dish of ice cream. Eleanor Weare of Ware is shown cleaning him up.

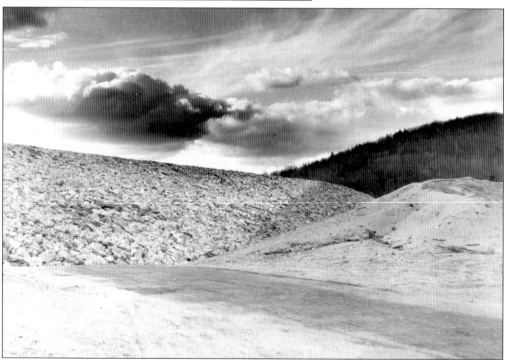

Dark clouds gather over the baffle dam section of the reservoir system, a silent witness to Greenwich Village, which lies 200 feet below the water.

No story is needed for this picture. The sign says it all.

Across America, People are Discovering Something Wonderful. Their Heritage.

Arcadia Publishing is the leading local history publisher in the United States. With more than 3,000 titles in print and hundreds of new titles released every year, Arcadia has extensive specialized experience chronicling the history of communities and celebrating America's hidden stories, bringing to life the people, places, and events from the past. To discover the history of other communities across the nation, please visit:

www.arcadiapublishing.com

Customized search tools allow you to find regional history books about the town where you grew up, the cities where your friends and family live, the town where your parents met, or even that retirement spot you've been dreaming about.